IMAGES
of America

CARVER COUNTY

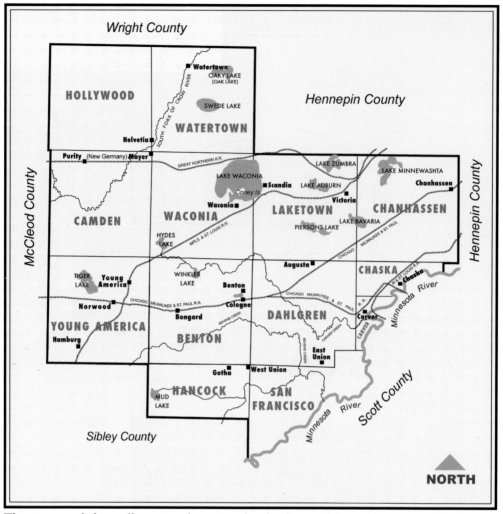

This is a compiled map illustrating the various locales discussed throughout the book. It is based on various 1800s and 1900s Carver County plat maps. (Illustration by Ruth Tremblay [2011].)

ON THE COVER: Sorghum was a popular sweetener, and many communities had a mill to provide the syrup. Household uses for it included spreading it on hot biscuits and as a sweetener in bread. It was an expensive crop for a farmer to grow due to the harvest being labor intensive. For high-quality syrup, sorghum stalks were processed by stripping the leaves by hand, crushing the stalks, and extracting and boiling the juice. Sorghum experienced a boom in production during the Civil War due to the rising cost of southern sugar. During the 1894 season, J.S. Hallin's sorghum mill near Bevens Creek in San Francisco Township produced an estimated 4,000 gallons of sorghum. A cream-separating station was operated in connection with the mill. (Courtesy of Scott Hallin [Fall 1896].)

IMAGES
of America

CARVER COUNTY

Ruth Tremblay and Lois Schulstad

ARCADIA
PUBLISHING

Published by Arcadia Publishing
Charleston, South Carolina

Printed in the United States of America

Library of Congress Control Number: 2011933816

For all general information, please contact Arcadia Publishing:
Telephone 843-853-2070
Fax 843-853-0044
E-mail sales@arcadiapublishing.com
For customer service and orders:
Toll-Free 1-888-313-2665

Visit us on the Internet at www.arcadiapublishing.com

We dedicate this book to

The citizens of the county past and present who saved
old photographs and postcards preserving history;

The libraries, archives, museums, and their staff and
volunteers who work to preserve and organize the
information necessary to preserve history;

And to all who supported us in the research and writing of this book.

In Memoriam:
Gerard Tremblay
May 13, 1927–December 12, 2010

CONTENTS

ACKNOWLEDGMENTS

The majority of photographs and postcards in this book were selected from the personal collections of current and former residents of Carver County. The book evolved from an interest in photographing barns and listening to the stories of the barn owners. Many of those same individuals also began sharing their personal photograph collections. A large number of postcards and photographs were needed, so help was enlisted from many more citizens of the county. Without their enthusiastic sharing of their collections and the accompanying stories, this book would not have been possible.

Contributions to this book were made by the following individuals: Liz Beiersdorf, Marilyn Braun, Maria DeWitt, David and Carolyn Effertz, Darlene Fasching, Warren Flusemann, Ron and Harriet Holtmeier, Marjorie Johnson, Nancy Keeton, Judy Koch, MariLu Luetke Peters, Rita Lundquist, Jaime Mackenthun, Marlene Magnuson, Jean Meuwissen, James Ohnsorg, Gerald and Geraldine Poppler, Patricia Probst, Bonnie Riegert, Charles and Catherine Sell, Alice Siewert, Rose Marie Sorenson, Theresa Spande, Vernis M. Strom, Marcia Tellers, Olvern Vinkemeier, John von Walter, Fritz and Jane Widmer, Larry Wigfield, and Leland Wyman.

We wish to recognize the following organizations and affiliated individuals for their contributions to this book, including Camp Fire USA Minnesota Council chief executive officer Marnie K. Wells and communications and marketing manager Tane S. Danger; East Union Lutheran Church congregation president Kent Hasse and Mike and Kathy Coleman; Chaska Historical Society's Tracy D. Swanson; and *The Waconia Patriot* editor Keith Anderson.

Three contributors have passed away since we began this work. In memoriam: Scott Hallin (1928–2010) and the Philippy sisters, Dolores Weinzierl (1919–2011) and Lois Weiland Fox (1922–2009).

We thank you for the generosity and hospitality you've shown us.

INTRODUCTION

Bounded on the north by Hennepin and Wright Counties, on the south by the Minnesota River and Sibley County, on the west by McLeod and Sibley Counties, and on the east by the Minnesota River and Hennepin County, Carver County is one of the "Big Woods" counties of Minnesota. The Big Woods was a vast tract of hardwood timber thick and heavy with oaks, elms, hard and soft maples, cottonwoods, and other varieties. Native Americans did not establish their permanent villages within the Big Woods, but it was their favorite hunting and trapping ground.

In the fall of 1851, following the treaty signing at Traverse de Sioux and Mendota earlier in the in the summer, settlers began to arrive in the area that later became Carver County. Legally, it was not until February 1853 after the ratification of the treaty that the area was open to settlement. By 1855, the government was permitting American soldiers who had been awarded military bounty lands for their service to sell their warrants or titles. Speculators began buying up these warrants. They then moved in and began laying claim to the land that would likely be the location of future villages. They also sold these lands at a higher price to settlers eager for land.

Land claims were also made under the Preemption Laws, but before the land was legally open to preemption it had to be surveyed. Surveying of the area began after the ratification of the Traverse de Sioux Treaty. Preemption allowed every settler who had been residing on his property to file for preemption rights for up to 160 acres at $1.25 an acre. In 1854, Congress extended the preemption privilege for Minnesota to include tracts of not yet surveyed public land, giving way to a rush for lands from 1854 to 1857. Claims were filed at a US Land Office. By 1854, there were six land offices in Minnesota; by 1856, there were eight.

On February 20, 1855, the Minnesota Territorial Legislature incorporated Carver County from parent counties Hennepin and Sibley. By an act on March 3, 1855, it was declared an organized county. The county was named after explorer and author Jonathan Carver, who traveled westward from Boston, Massachusetts, in 1776 to explore the Northwest, spending a winter with the Dakota tribe near the Minnesota River. The town of San Francisco was designated as the county seat until elections could be held. The first meeting of the commissioners was held in San Francisco in 1856. In the fall of 1856, an election was held with choices of Carver, Chaska, and San Francisco for county seat. Voters elected Chaska as the county seat and the town of San Francisco later became a ghost town.

The earliest Carver County settlers were predominantly German, Scandinavian, and Irish. Many were poor and carried their belongings on their backs on the journey to settle the land. Others purchased supplies and livestock from trading posts along the Mississippi and Minnesota Rivers. They faced harsh winters in simple shelters that they built with basic hand tools. Land was often cleared and plowed without the benefit of livestock to lessen the burden.

The following pages contain a glimpse of life in Carver County from the pioneer days of the 1850s through the 1950s. This work explores many aspects of county development that resulted from the hard work and perseverance of its pioneers, decades of social and economic growth, invention, innovation, and contributions to agriculture.

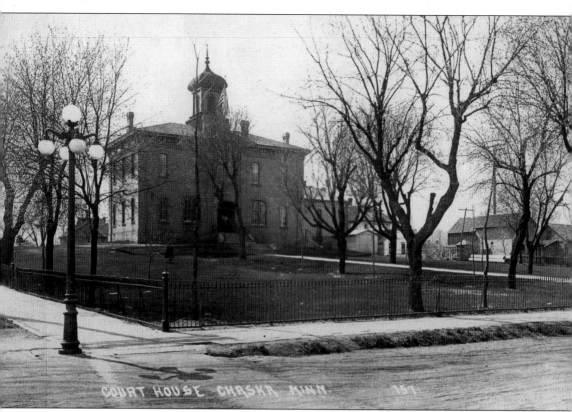

In 1857, the Shaska Company acquired all the land of the Chaska town site from George Fuller. The company deeded Lots 3 through 8 of Block 27 to the county for office buildings. The county issued bonds, but not enough were sold and construction of the courthouse was not completed before the 1857 financial panic. The county was unable to pay the bondholders who demanded their money, and the county thus defaulted. Following litigation spanning 13 years, a settlement was made, and the property was deeded back to the county. In February 1864, an ell and another addition were made to the courthouse, and the sheriff's residence was completed. In June 1865 and again in August 1896, tornadoes came through the area, causing the courthouse to sustain roof damage. In 1866, the county board moved ahead with the construction of jail cells in the basement of the courthouse. In 1879, the courthouse site was graded, and the iron fence was installed around the square and trees were planted. Through the years, there were many petitions to move the county seat to another location in the county, none of which were successful. This, the original courthouse, was torn down in 1966. (Courtesy of the Emma Anderson Mellgren family.)

One

COMMUNITIES AND STREET SCENES

Settlers were attracted to Carver County by its rich land, vast woods abundant with game, and its abundant water supply with fish and fowl. Many made the journey with other families connected by a common religion or ethnicity. As the population in the county increased, organized villages often emerged from these commonalities. More isolated communities faded into obscurity and became ghost towns.

By 1874, Carver County was divided into 13 townships: Benton, Camden, Carver, Chanhassen, Chaska, Dahlgren, Hancock, Hollywood, Laketown, San Francisco, Waconia, Watertown, and Young America. Villages in these townships included Benton, New Germany, Carver, Chanhassen, Chaska, Cologne, Mayer, Norwood, Waconia, Watertown, Hamburg, Victoria, and Young America. Norwood and Young America, originally separate entities, merged in 1997. Today there are 10 townships.

The townships of Hollywood, Watertown, Laketown, and Chanhassen form the northern boundary of Carver County. Settlers of Hollywood Township were predominantly of German and Irish descent. A German named Peter Karels first settled in the township in the fall of 1856. Originally Helvetia Township, it and Watertown Townships' boundaries were changed in 1858. In April 1860, Helvetia Township was renamed Hollywood Township.

Watertown Township was first settled in 1856 when Götaholm, a Swedish colony, was established on Swede Lake by Daniel Justus and a few other Swedes. A man of Swiss descent, John Buhler laid out the little town of Helvetia on the far western edge of the township in 1856. It was organized in April 1858, with Watertown being the significant settlement.

By 1855, the Swedish settlement of Scandia was established on the eastern shore of Clearwater Lake (Lake Waconia) in what would become Laketown Township. The township was organized in May 1858 under the name Liberty, and settlers were of Swedish and German descent. After growing dissatisfaction among the township citizens, one month later a meeting was held to reconsider the decisions of the first meeting. An early settler, John Salter, suggested the name be changed to Laketown for the large number of lakes within the township.

Chanhassen Township was organized in May 1858. Many beautiful lakes dot its landscape. Early settlers in the township included Joseph Vogel and Henry Lyman, who acquired land through the purchase of military bounty warrants. The name Chanhassen is believed to be composed of

two Sioux words meaning hard maple or sugar tree and was chosen because of the large numbers of sugar maples in the township.

A portion of the southern boundary of Carver County is marked by the Minnesota River. Along the river were Chaska, Carver, and San Francisco Townships. Chaska Township was organized in 1858 and held its first election in May of that year. The Village of Chaska was incorporated in 1871; it is the county seat.

Organized in 1858, Carver Township had seen its first settler in the winter of 1851–1852. The first meeting of the township, or "town," was held in May 1855 with an election of officers. Though platted in 1857, the village of Carver was not incorporated until 20 years later. By special act in 1877, the "Township of Carver" was set apart and incorporated as the Village of Carver. The village of Carver was a railroad junction, a mill town, and a steamboat landing.

Among the first settlers of San Francisco Township were the Bevens brothers, who arrived in 1853–1854 and settled by the creek still bearing their name, Bevens Creek. The town of San Francisco in this township was the first county seat.

The western border of the county is completed with Camden and Young America Townships. Camden Township was settled in 1856 by Nathanial Cole. Two early villages, Camden and St. Clair, became ghost towns. Mayer and New Germany are located in the township. The name New Germany was briefly changed to Motordale during World War I due to the animosity toward Germany.

Of German descent, Young America Township's first settlers arrived in the fall of 1855 and settled near Tiger Lake. Disagreement arose over the name of the township. It was initially named Young America before changing to Farmington. The name changed to Florence in 1858 and then in 1863 back to the original name Young America. Hamburg, Norwood, and Young America are villages located in this township.

Hancock Township completes the southern border of the county. It is the smallest township by area in Carver County and, until March 1868, was part of San Francisco Township. The majority of the population was of Irish descent, arriving in large numbers in 1856.

The remaining three townships of Benton, Waconia, and Dahlgren comprise the interior of the county. Benton Township was organized in May 1858. German pioneer Christian Hebeisen was the first to arrive in 1855. The villages of Benton, Cologne, and Bongard reside within its boundaries, and Bevens Creek flows through its southern region.

Waconia Township boasts beautiful lakes, rolling farmlands, and tracts of timber. Settled predominantly by Germans, it is believed that Ludwig Sutheimer and Michael Scheidnagel, who arrived in the spring of 1855, were the first permanent residents of the township. Its largest lake is Clearwater Lake (Lake Waconia). Near the southwestern shore, about a half-mile from the Village of Waconia, Clearwater Lake boasts 37-acre Coney Island.

Scandinavian (mostly Swedes) and German pioneers arrived in Dahlgren Township in 1853 and 1854. The township was organized by the name Liberty in 1863; in 1864, the township was fully organized. At the suggestion of the state auditor, the township name was changed to Dahlgren in honor of distinguished Union naval admiral John Adolph Dahlgren, a Pennsylvanian of Swedish descent. This township is the primary site of King Oscar's Settlement.

Early township governments played a key role in the county. During the Civil War, each township recruited and contributed soldiers to the Minnesota units of the Union Army. People were poor, and while there were many men willing to volunteer, they needed to be certain their families would be cared for in their absence. This resulted in many townships paying a bounty to their volunteer soldiers. Together, the townships furnished 588 men to the Union Army. In 1870, the township clerks began recording births and deaths and reporting them to the county, providing insight into the lives of early residents of the county.

This chapter will take the reader on an exploration of the locales within these townships.

The town of Carver was surveyed and platted in 1857 on 415 acres that a "sooner," Axel Jorgenson, had settled on in the winter of 1851–1852. Looking generally northeast from a hill above town, this view was taken by traveling photographer O.B. Benson. Notable structures from left to right in the background are the Enoch Holmes Elevator, the Anton Knoblauch Elevator, and the Minneapolis and St. Louis Railroad Bridge crossing the Minnesota River. The steeple in the foreground is the Swedish Lutheran Church. (Courtesy of the Leland Wyman collection [October 1893].)

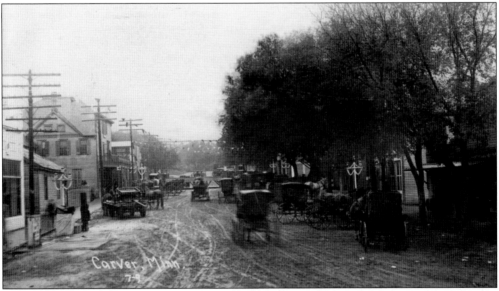

Pictured on the left in this Carver street scene is the State Bank of Carver; across the alley are a warehouse and the Central (Neunsinger) Hotel; across Fourth Street is the John Funk Lumber Yard. On the right side, the closest buildings are a barbershop and the Knoblauch Bank Building; across the alley are a printing shop, a harness shop, and three general store buildings in a row; across Fourth Street is the Funk Hardware building. High in the background is the Hastings & Dakota Railroad Bridge over Broadway. (Courtesy of Scott Hallin [c. 1908–1910].)

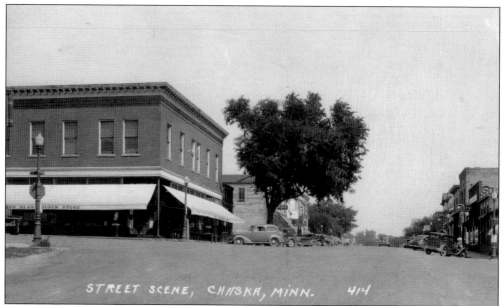

STREET SCENE, CHASKA, MINN. 414

Chaska was surveyed and platted in 1857 by John T. Halsted. This scene looking north from the intersection of Chestnut and Second Streets shows the numerous businesses that lined the street. Located on the northwest corner and built in 1903 is the Glass Block Store, which was owned by J.A. Schmidt. To the north are the Rex Theater and Chaska Drug. On the northeast corner is Leivermann-Son Meats, and O.H. Iltis, Jeweler is to the north. (Courtesy of Judy Koch.)

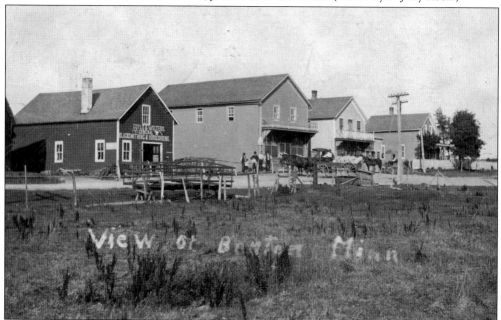

View of Benton Minn

Named after statesman Thomas H. Benton of Missouri, the village of Benton was surveyed in 1880 on land owned by Casper Kronschnabel and incorporated in 1881. The village charter was vacated in 1891 and, eventually, it was merged with the village of Cologne and later annexed by the City of Cologne. On the near left side is the Coyle & Welters General Blacksmithing and Horseshoeing business. (Courtesy of Rita Lundquist [1915].)

The town of St. Hubertus was platted in 1887 after the Franciscan Brothers relinquished the title to the property around St. Hubert's Catholic Church to the diocese. It was not until April 1896 that 35 men met and voted to incorporate the village with the more traditional name of Chanhassen. The first officers were elected in May 1896. In this scene of St. Hubert Street, St. Hubert's Catholic School is seen in the background on the left. (Courtesy of Theresa Spande.)

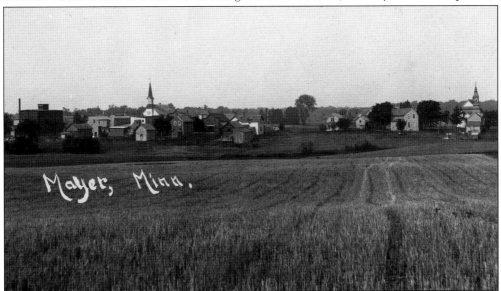

This eastern view of Mayer was taken from the farm of Fred Haueter Jr., whose father Fred Sr. and uncles Christian and Jacob staked claims on the present town site of Mayer in 1857. The Mayer Canning Factory and smokestack can be seen on the far left, and the steeple of the Zion Lutheran Church, built in 1905, is located to the right of the canning factory. The Zion Evangelical Church steeple can be seen on the far right. (Courtesy of Liz Beiersdorf [c. 1905–1910].)

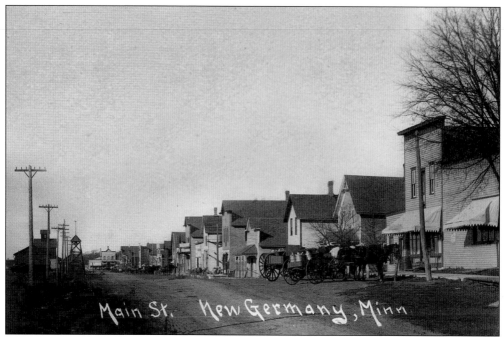

This view looks west from Bury's Store on Main Street in New Germany. On the far left is the New Germany Feed Mill, built in 1896 adjacent to the grain elevator. In the left foreground is the fire department bell tower. On the right is the Schlecter Hotel and Saloon with horse teams and wagons in front. (Courtesy of the David Effertz family [c. 1910].)

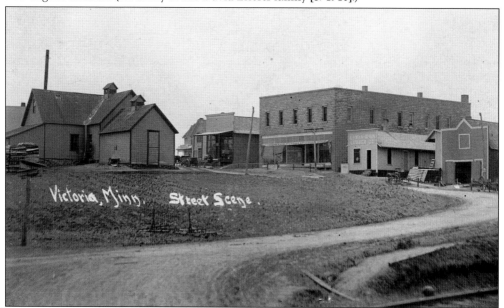

On the left in this Victoria street scene is the Victoria Cooperative Creamery Company building, constructed in 1897. Prominent on the right is the two-story Notermann & Son building, a general merchandise store that sold dry goods, groceries, and shoes. The Lyman-Irwin Lumber Company building is to the right of the Notermann & Son building, and to its left is the building that in 1909 became the Math. Grausam Hardware store. (Courtesy of Harriet & Ron Holtmeier [c. 1900].)

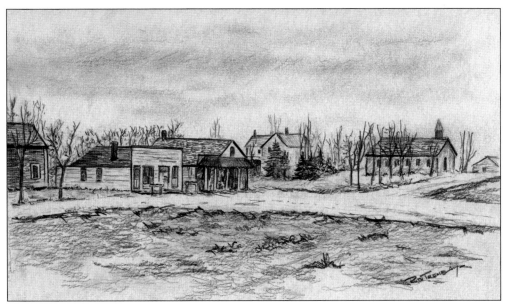

In 1853–1854, a few miles west of Carver, a Swedish settlement began that was initially named King Oscar's Settlement and later became Union Settlement and then East Union. From left to right, this illustration, based on an early 1900s photograph of East Union, shows the J.A. Mellgren Blacksmith shop, the A.J. Carlson home and store/post office, the business of A.P. Mellquist, the home of A.P. Mellquist, the District 21 East Union Public School building, and the creamery. (Illustration by Ruth Tremblay [2011].)

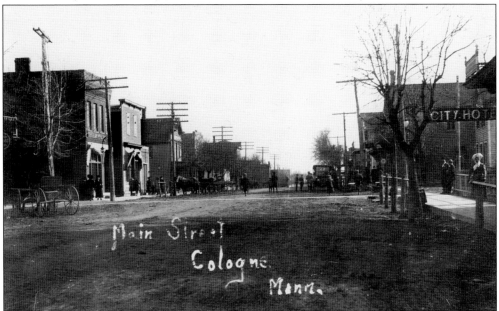

Incorporated in 1881, the village of Cologne was named after the city of Köln, Germany, by the Mohrbacher family, who had emigrated from an area near that city. On the left is the two-story brick State Bank of Cologne building; on the right is the City Hotel. Opened by John Jorissen on May 30, 1897, the property included a hotel, barn, icehouse, two lots, and a saloon run in connection with the hotel. (Courtesy of Marcia Tellers [1911].)

15

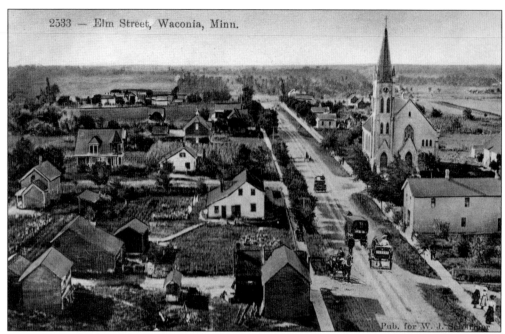

2533 — Elm Street, Waconia, Minn.

Owned by Roswell P. Russell, the site that became Waconia was surveyed and platted in 1857. His vision that the south shore of Clearwater Lake (Lake Waconia) would someday become a popular summer resort led him to lay out the town. Prominent in this street scene on Elm Street, looking south from First Street, is Trinity Lutheran Church. On the left side of the street are homes, farm buildings and fields, and dense woods to the south. (Courtesy of the Kim Mackenthun family.)

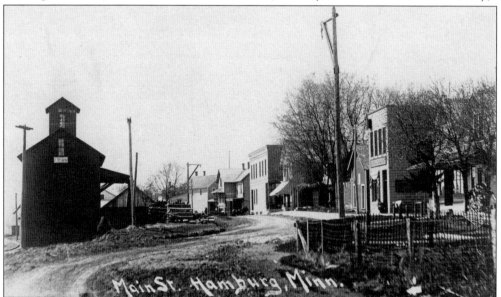

Main St. Hamburg, Minn.

Hamburg was incorporated in May 1900. The first election was held on May 15, 1900. In this scene of Main Street looking southwest, on the left is the Albert J. Truwe Elevator & Feed Mill. On the right are the Henry Dreier Harness Shop and post office, the State Bank of Hamburg, a well house or cistern, the Truwe store, the Hebeisen store, Mueller's Bar, and Mueller's Store. (Courtesy of the Fred Bergmann/Johann J. Mueller families.)

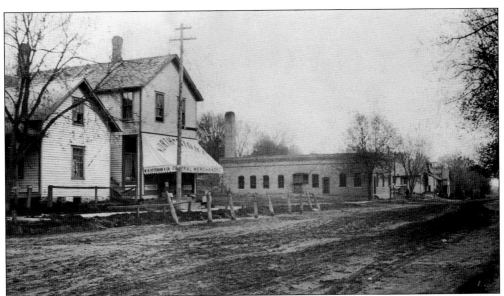

Incorporated on February 26, 1877, Watertown was surveyed and platted in 1858. It is located on the South Fork of the Crow River. In this scene of Lewis Street are, from left to right, the Peter A. Zachrison residence, the W.H. Peterson and Company general merchandise store, and the creamery. Lewis Street later became Lewis Avenue. (Courtesy of Marjorie Johnson [1909].)

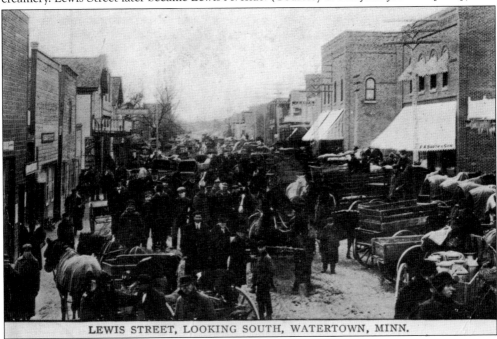

LEWIS STREET, LOOKING SOUTH, WATERTOWN, MINN.

Looking south on Lewis Street in Watertown, it is a cold winter Market Day with snow collecting on the horse blankets and street. The fourth building on the left is Zeyer's Hotel. On the right is the F.A. Barth & Son building, a general merchandise business. The store accepted cash or farm produce of all kinds for all goods at time of delivery. To the left of the F.A. Barth & Son building is the J.E. Grife Harness Shop, and to the left of that is the post office. (Courtesy of Liz Beiersdorf.)

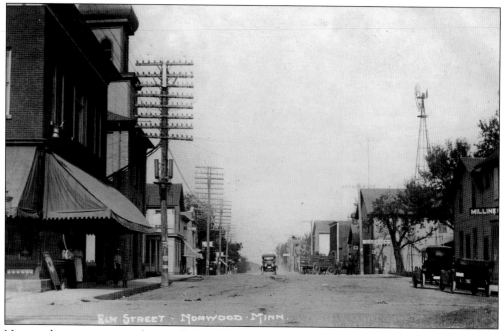

Norwood was incorporated as a village in 1881, having been laid out in 1872 with the building of the Hastings and Dakota Railroad. The presence of the railroad made it a shipping point for grain, livestock, and dairy products. Norwood was home to shops and stores, a bank, mills and elevators, an opera house, a creamery, and a newspaper. This scene of Elm Street shows, on the left, Palace Drug Store, the Norwood City Hall, and the post office; and on the right is a millinery shop. (Authors' collection [1916].)

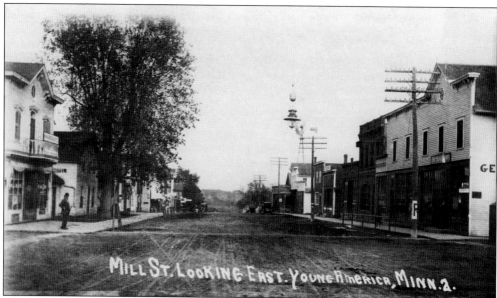

Young America was platted in the fall of 1856 by Dr. R.M. Kennedy and James Slocum Jr. on their land and incorporated on March 4, 1879, over 22 years later. This view shows Mill Street, now Main Street, which was the scene of many community events, including band concerts, street dances, and parades. (Authors' collection [1917].)

Two

ENTREPRENEURS

The land policies of the US government made it possible for anyone to secure a better life by owning their own land. Land in Carver County had just opened to settlement, and land speculators began buying up land for the purpose of planning towns. Some were interested in making a profit on the land, while others were entrepreneurs planning to operate businesses in the new town. These early entrepreneurs were usually very active in the community.

Trading posts along the Minnesota River were the only means of commerce until settlement began. A general mercantile was usually the first business established in the early towns and supplied many essential items. Their inventories were often limited. The typical items carried in the store were non-perishable food items, dry goods, staples such as coffee, tea, and spices, lanterns, matches, fabric and sewing notions, ammunition, hardware, hand tools, writing instruments and paper, medicines and liniments, oil and kerosene, household goods, and locally obtained perishable food. Early stores had a potbellied stove for heat and chairs for the customers to warm up while waiting for the clerk to fill their order. Business was transacted by bartering, credit on account, and cash; transactions were recorded in the store ledger. The general store often housed the post office and later the only phone in town. It was also a social place to catch up on the local happenings.

The arrival of increasing numbers of settlers drove diverse business development. Blacksmith shops, liveries, harness shops, hotels, saloons, drugstores, milliners, tailors, bakeries, confectioners, meat markets, furniture stores, hardware stores, and carriage makers were springing up in towns throughout the county. These businesses offered access to conveniences, alleviating some of the hardships of frontier life.

By 1900, diverse industries had sprung up in the towns of Carver County. Abundant water resources, rich productive farmland, and available transportation all contributed to the industrial development of the county. Water was used to power mills, provide ice for refrigeration, and was a component in some of the products being produced. Locating businesses near prime water supplies was not only a major convenience but also essential to the rapid growth of the county.

Farming was the predominant occupation in 19th-century Carver County and remained so until the mid-20th century. Many of these farmers had dairy herds. To become more efficient and profitable, they organized cooperative creameries; some towns had more than one. Most of the creameries had a butter maker on site, and high volumes of production were achieved. By 1960, Carver County was the self-proclaimed "Golden Buckle of the Dairy Belt." The creameries, mills, sugar factories, breweries, and canning factories produced flour, sorghum products, butter, and canned goods such as corn and beans from harvests brought to them by local farmers for processing.

Prior to the railroad arriving in Carver County in 1871, there were few options for transportation. Many settlers did not have horses or wagons and walked great distances for supplies; they were limited to what they were physically able to carry on the return trip. Minnesota barges and steamboats were the available means to transport goods into and out of the county, but they relied on the viability and extent of the river. The speed and efficiency of travel by rail provided a way to compete in new and more distant markets, making it an attractive method of transportation for local entrepreneurs.

The railroads and foresight of three local entrepreneurs contributed to the development of Norwood. The town was noted for wheat production, but the farmers had encountered problems with grain storage and expeditiously getting their harvest to market. In 1872, the construction of the Hastings and Dakota division of the Chicago, Milwaukee and St. Paul Railroad reached Norwood. During the same year, the first grain elevator was built in the town by the Ackermann brothers of Young America with a storage capacity of 10,000 bushels. In 1879, two new grain elevators were constructed: one by James Slocum, the Union Elevator, with a storage capacity of 50,000 bushels; and the other by M. Simonitsch, the Farmers' Elevator, with a storage capacity of 35,000 bushels. These men solved the problem of grain storage and made use of the railroad to efficiently transport grain to other markets. The entrepreneurs and the farmers all benefited.

Some successful local industries earned a reputation on a state and national level due to industrious and innovative entrepreneurs, such as William Bleedorn, Lucius Howe, and John Wessale and his sons Edward and Frank. In 1864, Bleedorn established the Watertown Bell Foundry. It was the only stock bell foundry in Minnesota and produced 3,000 to 5,000 bells each year.

Lucius Howe is credited with opening the first brickyard in Chaska in the mid-1850s after abundant high-quality clay deposits ideal for making bricks were discovered in the soil. At one time, there were 11 brickyards in operation. By the early 20th century, Chaska was producing 30 percent of all brick produced in Minnesota—40 to 60 million bricks annually. Buildings of Chaska brick, as it came to be called, can be found across the county and throughout the state, including the Grain Belt Brewery and Renaissance Square in Minneapolis and the state capitol in St. Paul, whose basement walls were built using over two million bricks. There are currently more than 60 Chaska brick farmhouses in the county. Chaska's settlement and economic development was directly related to the success of the brick industry.

Edward and Frank Wessale, with their younger brother George, led the Waconia Sorghum Mill and set out to "make or break" it in the sorghum business after their father, John, turned active interest in the mill over to them in 1914. Through their efforts to solve production problems and implement successful solutions, they steadily increased output while the great majority of the thousands of other sorghum mills across the country ceased operation. By 1929, the Waconia Sorghum Mill was touted as the largest pure sorghum operation in the world, with plants located in Waconia, Minnesota; Cedar Rapids, Iowa; and Fort Smith, Arkansas.

This chapter will introduce just a few of the hundreds of businesses and industries of the county.

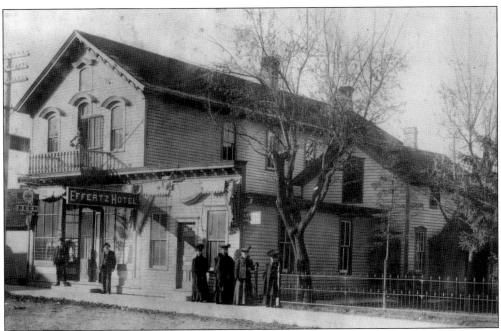

In the summer of 1872, Peter Effertz purchased one acre for $200 in Norwood. He intended to build his residence and engage in the contracting business. At the urging of Frank Warner of Carver, he instead opened the Effertz Hotel and Saloon the following spring. The hotel was expanded in 1878. He was principal organizer and president of the Citizens State Bank of Norwood when it opened in 1914. He operated a 220-acre stock farm, where he bred Red Polled cattle. In 1906, he was elected to the Minnesota House of Representatives. In the image above, ladies are gathered outside the "Ladies Waiting Room," a parlor for wives to sit, converse, and have tea while waiting for their husbands patronizing the saloon. The interior of the crowded saloon, with a central billiards table and gents playing cards, is shown in the image below. Hotel room rates in a 1918 advertisement in the *Norwood Times* were $1.50 to $2. (Both courtesy of David and Carolyn Effertz [above, c. 1900; below, 1904].)

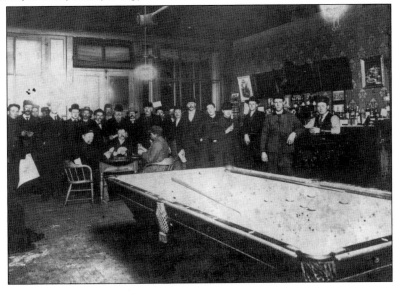

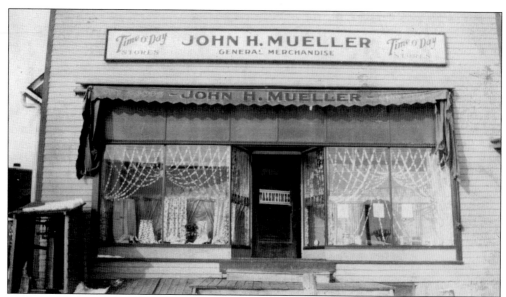

John H. Mueller was the son of F.F. and Anna (Daniels) Mueller. He lived in Hamburg all his life. Following the death of his father in 1925, John became the owner of the building constructed by his father in 1904. He decided to operate a general merchandise store in the building. He also bought and sold eggs and grains. During the first years, he hired clerks. Later, when his children were older, they assisted in the store. John Mueller Jr. bought the store from his father in 1961 and operated it until 1986. In the above image of the store exterior is a scale, and in the foreground is a post for tying horses. The window displays and door are decorated for Valentine's Day. The image below of the store interior shows a variety of merchandise available, including dishes, clothing, candles, and Time o' Day canned goods. It is Easter time. Pictured from left to right are Hilda (Mueller) Wendlandt, Arnold Oelfke, and owner John H. Mueller. (Both courtesy of the Fred Bergmann/Johann J. Mueller families [c. 1930s].)

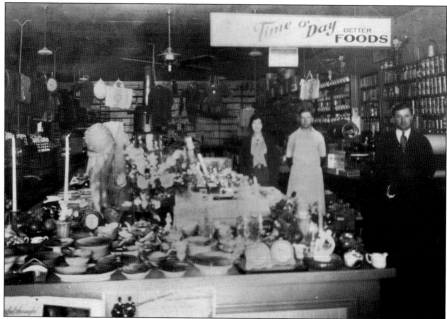

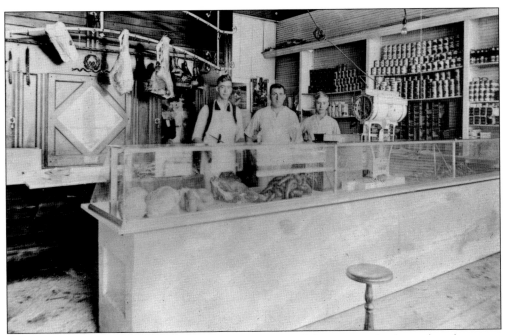

In January 1917, Arthur Mackenthun took over operation of the meat market located on the corner of Elm and First Streets in Waconia, purchased from J.H. Dickhudt & Son. Sawdust covered the floor, carcasses hung from meat hooks, and customers sat on stools while the meat cutter cut the pieces of meat requested. Shelved canned goods consisted of a variety of pork and beans, catsup, canned sardines, and mustard. Pictured from left to right are Arthur A. Mackenthun, J.H. Dickhudt, and Harvey Mackenthun. (Courtesy of the Kim Mackenthun family [1917].)

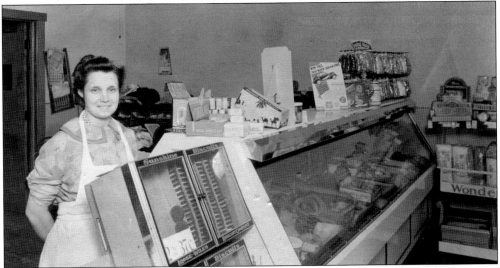

Alois "Cleaver" Effertz learned the meat-cutting trade working part-time at Mackenthun's Meat Market in Norwood during his youth. In January 1935, Radde's Meat Market in New Germany was destroyed by fire. Fred Gohlke purchased the vacant lot where the business stood and built a meat market on the site. Effertz took over the operation in October 1935. His wife, Elizabeth (Braunworth) Effertz, is pictured behind the meat counter. (Courtesy of David and Carolyn Effertz [1939].)

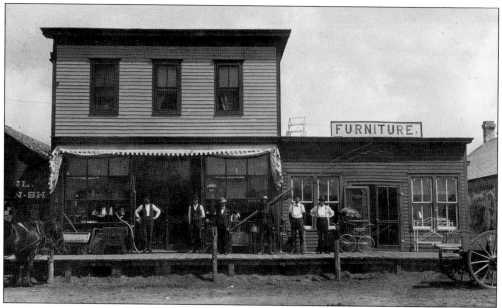

Augusta, now a ghost town, was located in Section 3 of Dahlgren Township and a stop on the Chicago, Milwaukee and St. Paul Railroad line. The Augusta Store, a general merchandise store, housed a saloon and post office. During the community's existence there was a depot, blacksmith shop, hardware store, feed mill, lumberyard, elevator, bank, barbershop, dance hall, creamery, and ballpark. (Courtesy of Gerald and Geraldine Poppler [before 1900].)

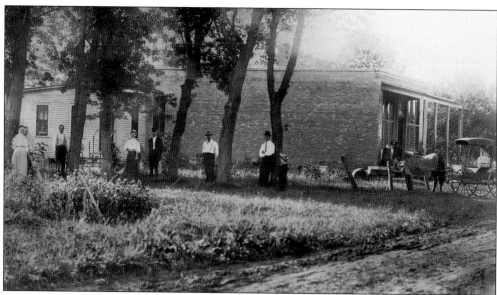

By the summer of 1892, the Gotha Store had outgrown its building. Owner Vitalis Ahlen erected a 30-foot-by-50-foot structure with bricks hauled by horse-drawn wagons from Chaska to the building site. The new building housed the store and post office, and the old building was used for storage. Ahlen was appointed postmaster in 1884 and held the post until 1902 when the post office was closed. The store was in Section 2 of Hancock Township across the street from the Gotha Creamery Company. (Courtesy of Marcia Tellers [1909].)

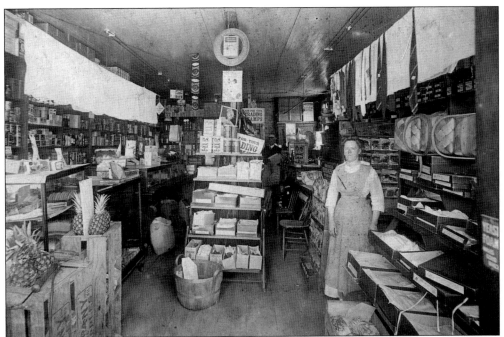

The W. H. Peterson and Company general merchandise store was located on Lewis Street in Watertown. At age 16, Minnie Peterson began assisting her father in the store, taking it over after his death in 1914. Penny candy was in a glass case. Customers chose cookies from boxes, bringing them to the counter to be weighed. Fruits and vegetables were chosen from crates on the floor. The store was open Saturday evenings. Folks came in to shop for Sunday dinner and catch up on news. Minnie's brother Amos, who started the Watertown Ice Company in 1916, delivered ice for the store icebox. Milk from the creamery next door was stored in the icebox. Amos harvested ice on nearby Oaky Lake (Oak Lake). After Minnie died in a 1931 car accident, Amos took over the store and operated it until his death. Above, in the background of the store interior, is an unknown, well-dressed gentleman, and in the foreground is Minnie Peterson. In the image below, Amos is pictured in front of his Model T delivery trucks holding ice clamps used for deliveries. (Above, courtesy of Marjorie Johnson [1900]; below, Marlene Magnuson [c. 1920s].)

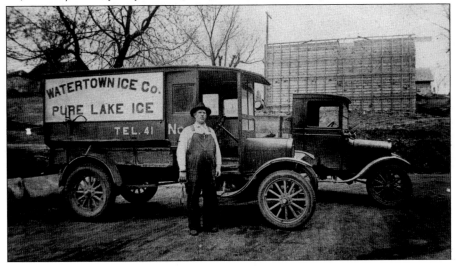

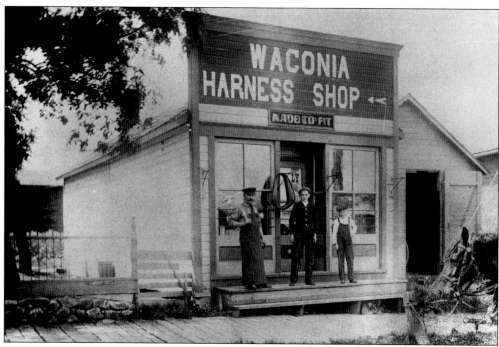

Alphonse Philippy Sr. was born in Malmedy, Germany, in 1852. At age 32, he embarked for America, settled in Farmington, Minnesota, and worked as a harness maker. In 1885, he married Barbara Schneider, a seamstress from Württemberg, Germany, and moved to St. Paul. In 1902, they moved to Waconia, where Alphonse owned and operated the Waconia Harness Shop for 35 years. In 1929, the harness shop expanded its services to include shoe repair. Alphonse Sr. retired in 1937 at age 85. Unable to pass his business on to his son, whose death occurred January 1936, he sold the business to John Otten of St. Michael in July 1937. Alphonse died two years later. In the image above, from left to right in front of the harness shop, are Alphonse Philippy Sr., Alphonse Philippy, Jr., and Paul Philippy. The image below shows Alphonse Philippy Sr. inside his harness shop. (Both courtesy of Rose Marie [Philippy] Sorenson [above, 1912].)

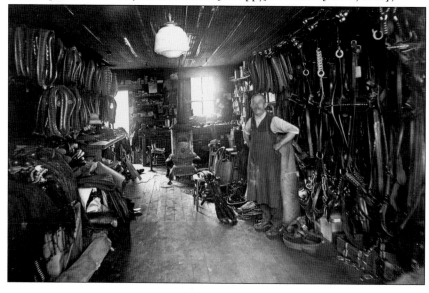

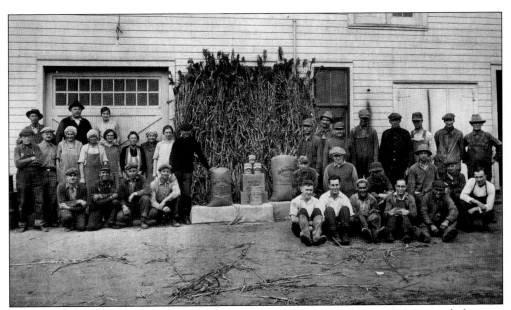

Built in 1901, the Waconia Sorghum Mill was destroyed in the August 1904 tornado but was rebuilt. After transfer of leadership in 1914 from John Wessale to his sons, Edward and Frank, mill output steadily increased. By 1929, the mill was touted as the largest pure sorghum operation in the world. Mill workers posing with sorghum stalks and sorghum products are Anna Wessale (standing, third on left from center); August Melchert (standing, third on right from center); and Anton Wessale (standing, fifth on right from center). The mill was put up for sale in 1933. (Courtesy of Liz Beiersdorf [c. 1926–1933.)

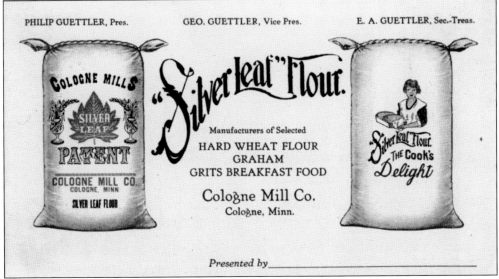

In 1881, Dahlgren Township farmer George Guettler and Gerhard Bongard, the station agent at Cologne, founded the Cologne Milling Company, millers of Silver Leaf Flour. Prior to the mill's construction, many residents traveled as far as Minneapolis for their flour supply. After construction, wheat was brought in from all over the area in exchange for flour. Mill capacity by 1885 was 130 sacks per day. By 1916, Silver Leaf Flour had become a household name and was synonymous with quality. (Courtesy of Marcia Tellers.)

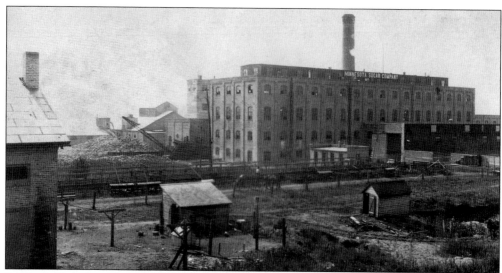

In 1905, the Carver County Sugar Company came into being as a result of the American Beet Sugar Company looking for a new sugar beet–processing site in Chaska. The first beets were being processed in the fall of 1906 at the new three-story facility that took an estimated two million bricks and $750,000 to build. During the first 120-day campaign that began about November 1, forty thousand tons of beets were processed. It was renamed the Minnesota Sugar Company in 1911. (Courtesy of the Emma Anderson Mellgren family.)

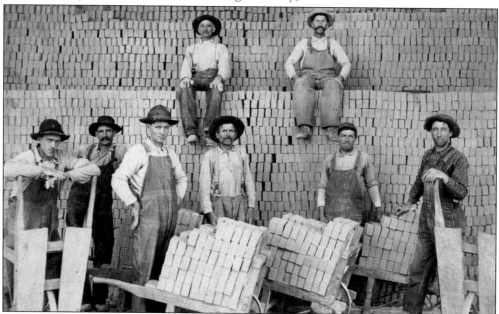

Chaska's clay-rich soil, the influx of skilled German immigrants, dense timber to fuel kiln fires, and a river location providing early transportation contributed to the rapid growth of the town's brickyard operations. By the mid-1860s, Chaska's four major brickyards produced an average volume of 3.5 million bricks annually. Brickyard laborers at a Chaska brickyard are pictured here. From left to right they are (front row) William "Bill" Griep, Herman Tiedeman, Rudolph Schoen, Mr. Neubert, and two unidentified; (back row) John Bierlein and August Boldt. (Courtesy of the Chaska Historical Society.)

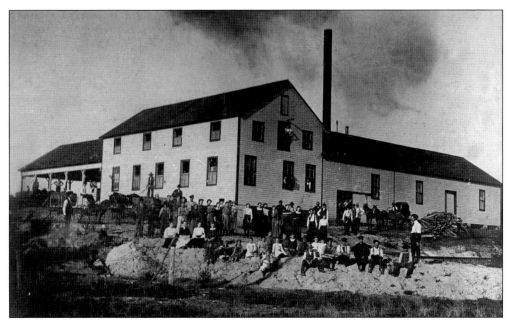

The Mayer Canning Factory was built in 1900 by local farmers but had to file for bankruptcy in 1909. A receiver was appointed, and later that same year H.P. Kusske purchased the business. Corn and beans were processed and packed at the factory. On August 17, 1923, the factory was consumed by a fire originating in a second-floor storeroom. It was just in the last year prior to the fire that the factory had been purchased by William H. Smith of Winthrop. (Courtesy of the Leland Wyman collection.)

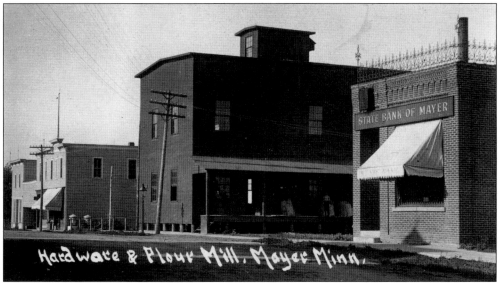

James J. Ponsford built the State Bank of Mayer in 1900. Traveling to Minneapolis in 1895, H.P. Kusske and C.F. Gongoll secured materials to build the Mayer Flour Mill. By 1900, Kuske was in partnership with G.A. Gatz producing White Rose Flour. In a 1911 partnership with Ferdinand Schmidt, H.J. Hill entered the hardware business; four years later, he became the sole owner. From left to right are the H.J. Hill Hardware store, the Mayer Flour Mill, and the State Bank of Mayer. (Courtesy of Liz Beiersdorf.)

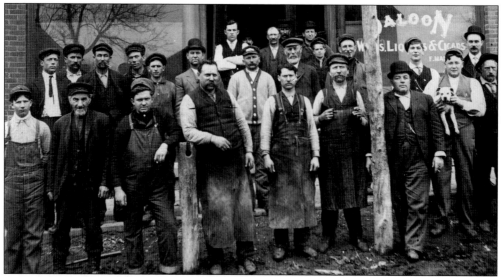

Mayer businessmen in front of the Lorenz Saloon are pictured from left to right as follows: (front row) Carl Lenz, Frank Budtke Sr., Ed Zellmann, Fred Hein, unidentified worker from Hein Blacksmith Shop, Rudolf Kratzke, Fred Scheidegger, Art Hahn with dog, and Carl Felske; (middle row) Hans Simons, unidentified, Fred Harloff, Henry Elling, Ernest Koehler, Otto Reich, William Westermann (light sweater, buttoned), August Ninnemann, Henry Koehler, Adolph Stark, Louis Gerber, and Dr. Emmerson; (back row) Ed. Bergs, unidentified, Ferd. Thies, Paul Hoese, and unidentified. (Courtesy of Liz Beiersdorf [March 1911].)

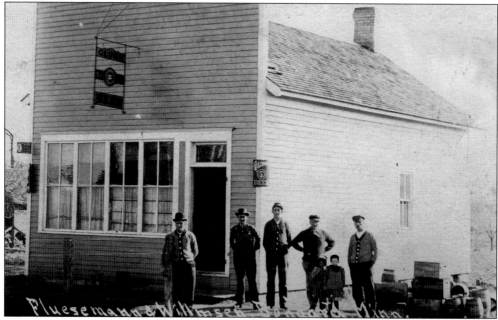

Prior to 1910 when this building became the Fluesemann & Willmsen Saloon in Bongard, it had served as the District 28 School on the Bongard farm and a pig barn on the Winkler farm. In 1928, it was sold and used as the town hall. Pictured from left to right are unidentified, John Willmsen, Edward Willmsen, unidentified, and Gerhardt Flusemann and Gerhardt's children Gertrude and Anna. (Courtesy of Warren Flusemann.)

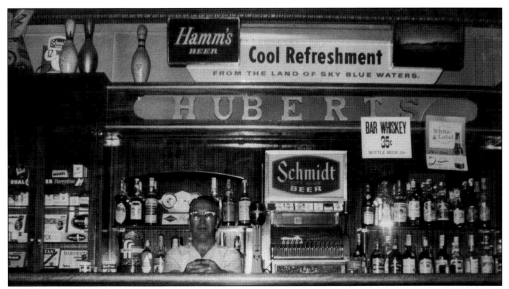

In 1928, Hubert W. Mueller purchased a Hamburg recreation center and ice cream parlor from Herbert H. Kloempken. In the early 1900s, the business had been a saloon. The recreation center had pool tables, and soft drinks were sold during the Prohibition era. Hubert Mueller's Saloon became affectionately known as "Hubie's Place." He operated the saloon with his wife, Anne (Maser) Mueller, until selling it in 1963. Pictured behind the bar is Hubert W. Mueller. (Courtesy of the Fred Bergmann/Johann J. Mueller families.)

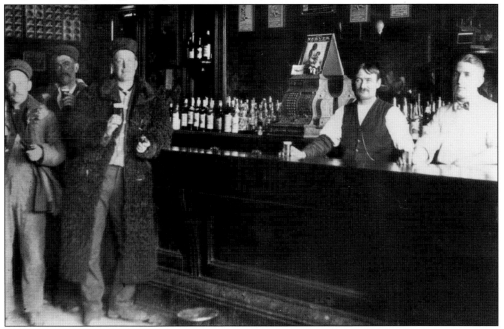

Harry King and William Stender were in partnership in the King and Stender Saloon in New Germany. The building's lower level was a saloon and dwelling, and the upstairs was used as a dance hall. In 1912, Dr. Grivelli Sr. located his office upstairs over the saloon. Pictured here is the saloon interior with patrons enjoying a nip; the bartenders wait to fill requests. A spittoon sits on the floor in front of the bar. (Courtesy of David and Carolyn Effertz.)

By executive order, Franklin D. Roosevelt established the US War Production Board (USWPB) during World War II to regulate the allotment of scarce materials vital to the war effort. Before construction of the Molnau Implement Company building in Chaska began in 1944, the USWPB had to approve an "Authorization to Begin Construction and Allotment of Controlled Materials" to ensure that steel, copper, or alloy metals were not being used in the construction of the building. (Courtesy of Judy Koch [c. 1944].)

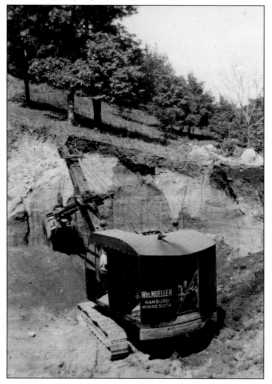

With the appearance of cars and rutted-up roads, William Mueller saw the opportunity in road construction. In 1919, he sold his dray and livery business in Hamburg. William Mueller Road Construction began using horse-drawn dump wagons, shovels, and one-hand scoops he had used in his dray business. Through the years, he hired manual labor and purchased increasingly more modern equipment. When his son and sons-in-law joined the business in 1937, it became Wm. Mueller & Sons. Today, the fourth generation is involved in the operation. (Courtesy of the Fred Bergmann/ Johann J. Mueller families [1938].)

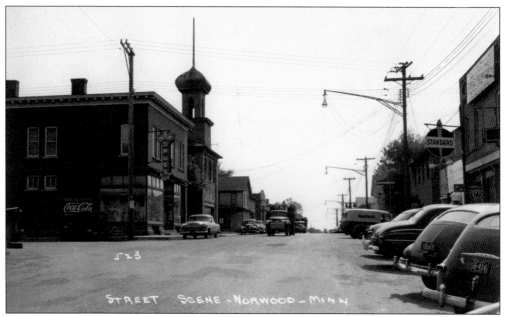

The Knutson Drugs building on Elm Street in Norwood originated as the Palace Drug Store, built in 1892 by Henry Fabel, Norwood's first druggist. In addition to dispensing prescriptions and other medical supplies, over the years the business accommodated many needs of the citizens, including sale of baked goods and liquor, and it housed the first telephone switchboard, an ice cream parlor, and a dentist's office. On the left are Knutson Drugs and the onion-spired Norwood City Hall. (Authors' collection [1953].)

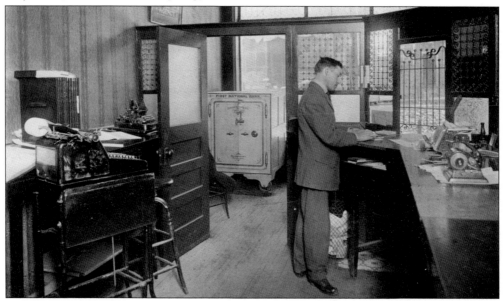

In 1907, Charles H. Klein and his brother Christ P. Klein, successful brick industry entrepreneurs, purchased controlling shares of the First National Bank in Chaska. That same year, the bank building was constructed at 214 North Chestnut Street. Charles Degen is pictured at the teller window of the bank. In 1929, a new building was erected on the opposite side of Chestnut Street that housed the bank, post office, and drugstore. (Courtesy of the Chaska Historical Society [c. 1920].)

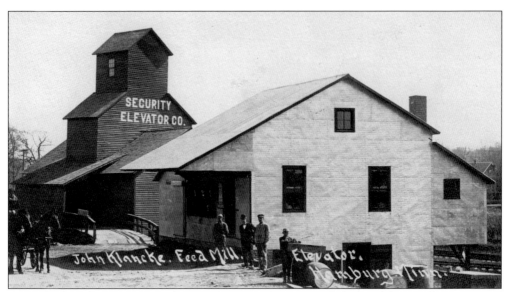

John Klanke was very interested in machinery and recognized the need for a mill. Opening of a mill meant area farmers no longer had to take their grain to Carver to be ground into flour. The Klanke Feed Mill and Elevator pictured here were built by John Klanke in 1908 and located on the corner of Railroad and Henrietta Streets in Hamburg. It was a larger and more efficient mill than the one he started with in 1905. (Courtesy of the Fred Bergmann/Johann J. Mueller families [c. 1910–1920].)

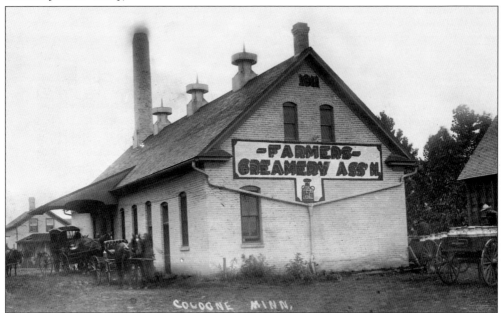

In 1911, the Farmers Creamery Association in Cologne replaced the original 1890 wood frame building with this new brick structure. The association was a community venture to market dairy products. Early stockholders included Adam Mohrbacher, Henry Meuwissen, Conrad Pfleghaar, Henry Harms, Peter Jorissen, and Otto Harms. Farmers are seen here bringing in, by horse-drawn conveyance, their whole milk to be separated and the cream to be made into butter. (Courtesy of Marcia Tellers.)

By 1904, local farmers had organized and purchased this creamery, built in 1902, just east of Hamburg. They immediately built an addition with plans to run four separators. August L. Radtke was retained as the butter maker. In 1908, he was awarded first place in the Minnesota State Fair butter-making contest. The home on the left was built about 1909 as a residence for the butter maker. (Courtesy of the Fred Bergmann/Johann J. Mueller families.)

East Union's Creamery

Farmers Co-operative at East Union, Carver County, Minnesota, on Route 1, Carver
New building erected in 1928. Prompt and reliable service.

The Farmers Cooperative Creamery in East Union became operational in the summer of 1897 and by December was receiving an average of 8,500 pounds of milk every other day. A.P. Mellquist and Peter Kleven Jr. played significant roles in the early days of creamery operations. Pictured on the left is the residence provided by the creamery for the butter maker and his family. On the right is the new creamery building, erected in 1928. (Courtesy of Vernis M. Strom [1931].)

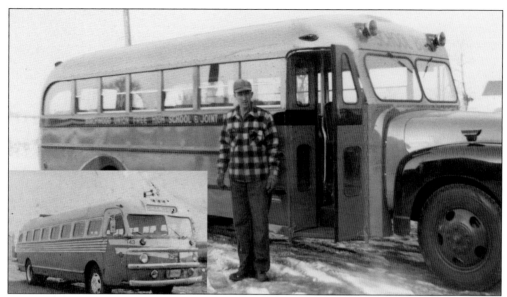

In 1936, Victor Koch began transporting students from Mayer to Waconia in Charlie Best's 1936 Desoto. For two years, he operated his bus service and drove his milk route for Best. In 1938, he purchased Best's automobile. The Waconia School Board approached Victor to buy their buses without cash; he agreed and $50 per month was withheld from his contract as payment. The main image depicts Victor standing next to a Koch Bus Service school bus; the inset in the lower left is Koch's first motor coach, purchased in 1952. (Courtesy of Judy Koch.)

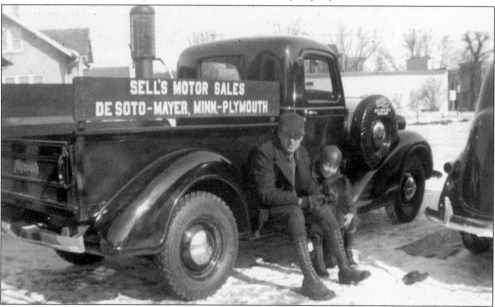

In 1927, O.D. Sell began building a brick structure intended to be a store and confectionery in Mayer. During the construction process, ownership changed to his son Elmer. Elmer set up shop in the building and began selling DeSoto and Plymouth automobiles, as well as appliances, and provided electrical wiring and general repair services. Pictured here is Charles Sell (right), Elmer's son, sitting on the running board of the Sell's Motor Sales Plymouth pick-up truck with Gilbert Hasse. (Courtesy of Charles Sell [c. 1934].)

Three

RURAL LIFE

Settlers arriving once land opened for settlement in 1853 found travel difficult because there were no established trails or paths. Many people arrived with only the provisions and tools they could carry. Obtaining more provisions often required a long walk, sometimes as far as St. Paul. In addition to tools, they brought seed potatoes, beans, corn, and other seeds. The abundant timber and water supply of its lakes and streams made land in Carver County very appealing to settlers despite the remoteness and isolation.

The early farmers chose wooded land near water so they could have a fuel supply, building materials, water, and food sources. The first task was to erect a rainproof, windproof shelter, even if temporary. Erecting a shelter cleared a little land on which to raise food for the family and livestock. In the spring, potatoes, beans, corn, and other vegetables were planted on the newly cleared land.

As early farmers continued to clear their land, they utilized the logs to build homes, barns, and fences and as a fuel supply. Families kept a good supply of dry, split wood in short lengths on hand at all times to provide fuel for heat, cooking, and washing. Furniture items and farm tools were also fashioned using the wood supply. Items included beds, hooks for hanging clothing, the moldboard for the plow, a harrow, whisks, brooms, and a wooden bin to save ashes from the fire for making soap. As sawmills began operating in the county, multi-room wood frame homes with wood floors and possibly a second story became more common.

Hand tools were used to dig up the earth and plant small patches of corn or grain by hand—a slow job. Planting two to three acres in a day was a big effort. After 1860, wheat became the common grain sown. Taking a number of years to remove old stumps, large tree roots, and rocks from a cleared area, the farmer first planted his crops around them. As large areas were completely cleared, oxen or horses were used to pull the plow. It was the late 1800s before labor and timesaving farm implements were in common use. Farmers found that the new implements worked better being pulled at a faster pace by horses than at the slower pace of the oxen. Farmers replaced oxen with horses on their farms.

The years of initial settlement until 1870, when farmers were just establishing their farms, were considered the years of "subsistence farming." During the years from 1870 to 1895, nearly all fields were sown in wheat, hence it was considered the "wheat era." From 1895 forward, farms were well established and were raising dairy cattle, hogs, and poultry; crops were raised for human and animal consumption. This defines "diversified farming."

History reveals the optimism, hard work, perseverance, ingenuity, and inventiveness shared by county residents. Three Carver County farmers, Wendelin Grimm, Henry Lyman, and Andrew Peterson, personified these ideals, making major contributions to agriculture.

Wendelin Grimm came to America from his German homeland in 1857 carrying a small bag of alfalfa seeds. He planted the seeds in the spring of 1858 and each year thereafter saved the seeds of the healthiest surviving plants and planted them the following season, ultimately cultivating a northern winter-hardy strain of alfalfa.

Henry M. Lyman, a Massachusetts farmer, brought with him six apple trees and seeds he planted in the spring of 1853. As a member of the Minnesota Horticultural Society, he set up an official apple "Trial Station" on this farm, keeping detailed notes of his experiments that resulted in many new apple varieties to his credit.

Andrew Peterson journeyed from his Swedish homeland in 1850, arriving in Carver County in 1853, keeping detailed diaries of his life and travels that later became a major historical record of pioneer life. He is noted for his experiments with apples and pears and is credited with cultivating over 200 varieties of winter-hardy Minnesota apples.

Carver County has the distinction of having the most existing round barns in Minnesota. Two of the six Carver County round barns are truly round and four are octagonal, but all of them are categorized as round barns. To truly appreciate Carver County's round barns, it is necessary to understand how they came to be, why they were efficient, and why they vanished.

The origin of the round barn goes back to 1794 when construction was completed on George Washington's 16-sided barn. The first true round barn constructed in the United States was in 1826 in a Shaker community in Hancock, Massachusetts.

A correctly built round barn features a self-supporting domed roof that allows for a spacious haymow and a deep central silo. The interior silo did not require siding and less scaffolding was needed for construction, resulting in 34 to 58 percent less materials for construction. The exterior wall, if built utilizing the lineal strength of the lumber (much like a hoop barrel), and the circular shape of the barn offered superior strength and wind resistance.

Octagonal barns, with their additional framing and sides, do not share the same wind resistance as a true round barn nor the economy of building materials. Octagonal barns require heavy and expensive framing, and the walls are difficult to securely join. The additional sides offer greater opportunity for wind damage.

The floor plan is much like a wagon wheel, with the silo and feed alley located at the hub and the litter alley at the outer perimeter of the wheel. At feeding time, the cows faced the silo, and feed was distributed around the alley using a cart that was returned to the silage chute for the next feeding. This layout saved time and labor.

A true round barn offered strength, convenience, and labor economy, but few people were skilled in its proper construction. Farmers were reluctant to invest in an unproven idea and opted for conventional barn designs. By the 1920s, laborsaving automated farm equipment became available with few options for round barns, resulting in the demise of round barn architecture.

This chapter introduces farm implements and tools of years past, along with the skills and innovation of those employing them.

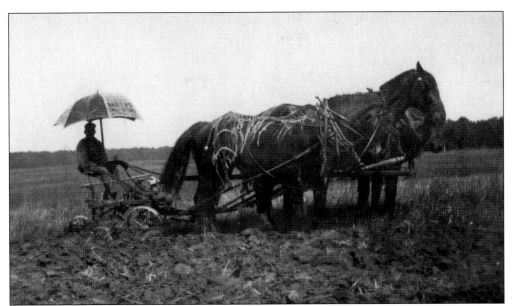

Plowing turned under the remains of the old crop and other nutrients, readying the field for the next crop to be grown. By 1840, most plows were made of cast iron. The sulky plow of the 1870s was pulled by three horses. Gang plows pulled by four or five horses soon followed on the market. Glenn Beiersdorf (1905–1996) is riding on the plow, guiding his horses in a straight line, and an umbrella is protecting him from the heat of the sun. (Courtesy of Liz Beiersdorf [1930s].)

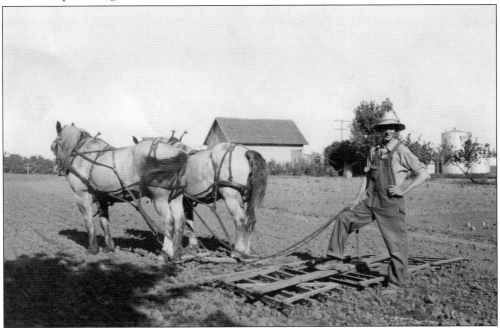

Harrows were used for leveling and smoothing the soil for planting. Early harrows were fashioned from tree forks with wooden pegs driven into them, and later they had metal spikes and rods attached to a wooden frame. For some crops, the harrow is used after planting to cover the seeds. Fine broken-up earth made it easier for the roots of the plants to spread. Jerry Flusemann, pictured here, farmed with horses until 1947. (Courtesy of Warren Flusemann.)

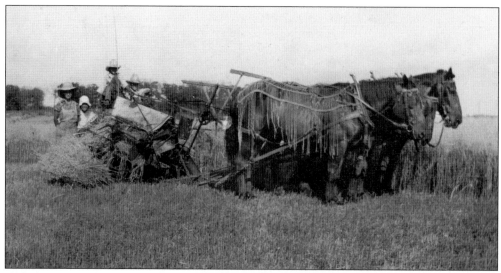

Early farmers used the sickle, the scythe, or the cradle to cut grain. In the early 1880s, Minnesota farmers began using the grain binder. It cut the standing grain, formed it into a bundle, and secured the bundle with wire or twine. Strong horses were used to pull this binder on the Klatt farm in Laketown Township. By the 1930s, production of grain binders slowed dramatically with the beginning of the transition to the combine. (Courtesy of Judy Koch [1930s].)

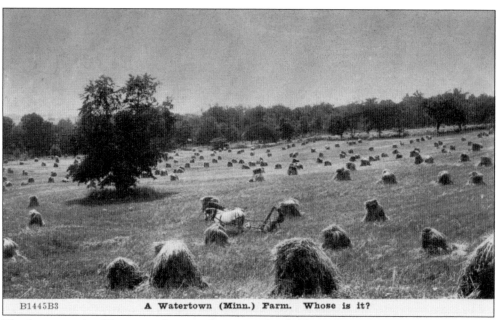

B1445B3 A Watertown (Minn.) Farm. Whose is it?

The farmer on this Watertown farm is riding across his field on a horse-drawn mowing machine. The field has been cut and grain tied into bundles. The bundles have been set into shocks to sufficiently ripen or dry for threshing. The shocks easily shed water in the case of rain. (Authors' collection [1910].)

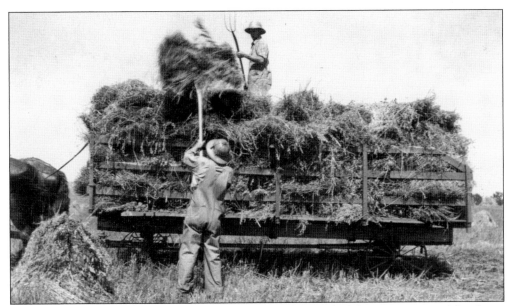

The grain has sufficiently ripened in the shocks. Now begins the laborious process of threshing, which separates the grain from the stalks. Allen Luetke (left) and John Raether act as "bundle haulers," pitching the shocks onto the horse-drawn wagon to be hauled to the threshing machine. (Courtesy of the Luetke family [1930s].)

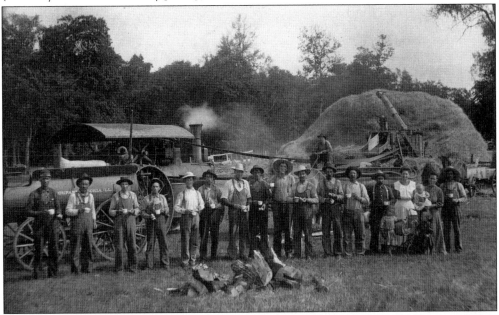

Farm women put together may meals at threshing time, including morning and afternoon lunches brought to the field. This Otto Quaas threshing crew is using a Reeves steam engine with an Avery water wagon on the William Mottaz farm in Waconia Township. Pictured from left to right enjoying lunch are Otto Quaas, Frank Hildebrandt, Albert Sell, Frank Borchardt, Julius Borgmann, Gust Hoeft, unidentified, Charles Quaas, Edwin Gongall, Bernard Sell, Wm. Hildebrandt, Pete Mottaz (Rheinhold), Ed Mottaz, Mrs. Wm. Mottaz, Mrs. Ed Mottaz and her children, and W. Mottaz; seated in back is Albert Luetgers. (Courtesy of Alice Siewert [1909].)

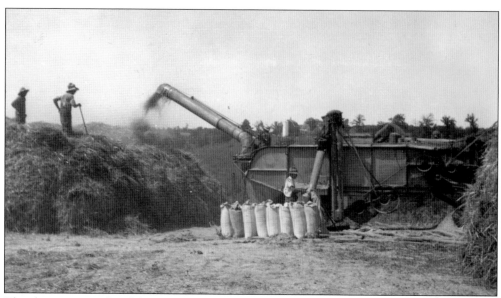

Threshing crews endured dirt, sweat, chaff, and heavy work. Each member of the threshing crew had a specific job to accomplish. In this scene, one man (the "separator tender") is watching over the process from atop the rear of the thresher, one man is sacking the grain, and the threshing machine is blowing the straw to a pile. Two men are spreading the straw to create a stack, the least desirable job but one that required skill. (Courtesy of the Luetke family [1930s].)

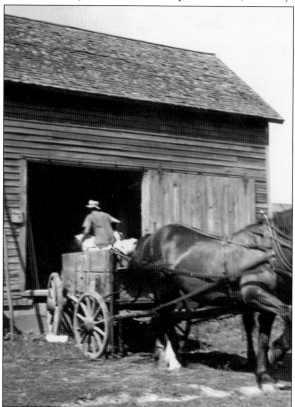

After being filled at the threshing machine, the sacked grain was loaded on a horse-drawn wagon and hauled to storage. The horses had to be dependable and not easily spooked. Threshing was noisy, and the horses remained hitched and stood unwatched for hours. Here the grain sacks are being unloaded into the granary, the farm storehouse for threshed grain. This photograph was taken by A.C. Stelling. (Courtesy of the Luetke family [early 1930s].)

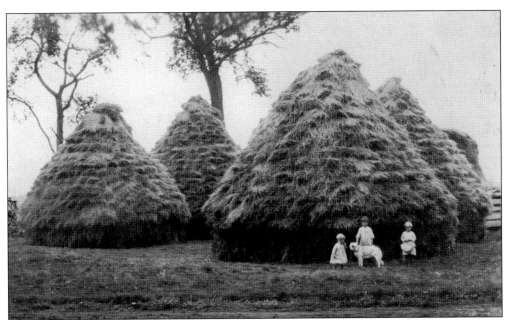

The harvest is complete, the straw has been stacked, and the chaff has been disposed of. A level, well-rounded, firmly built stack was critical to the stack withstanding wind and shedding rain. The straw was used for cattle fodder and bedding until the next harvest. Once the harvest was complete, planning began for the next year of plowing, harrowing, and planting. Pictured from left to right in front of the stacks are Bernice, Verna, and Esther Klatt. (Courtesy of Judy Koch [c. 1920].)

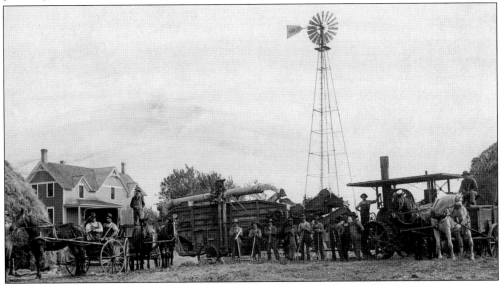

Threshing required a great deal of labor. This crew on the Ferdinand Ohnsorg farm in Chaska Township worked in the hot summer sun to complete the harvest using a Minneapolis Threshing Machine Company thresher and a Huber steam engine. In the 1930s, tractors replaced steam engines, and by the 1950s the combine replaced the threshing machine. Pictured standing on the steam engine is Anton Ohnsorg, and just below him is Ferdinand Ohnsorg. (Courtesy of James Ohnsorg [c. 1913].)

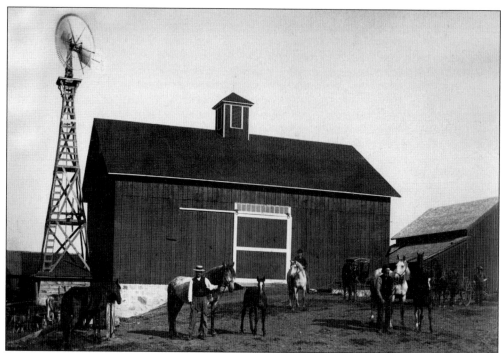

Henry Lyman believed agriculture was more than a way of living—it was meant to be advanced. He became a member of the Minnesota Horticultural Society in 1891. He is known for the Lyman's Prolific, a crab apple tree; the original tree on his Chanhassen Township farm was 40 feet in diameter. Pictured in front of the horse barn on the Lyman farm is Henry's son Arthur (on the left in the white shirt, holding the horse), and on the right (standing by the white horse) is Henry Lyman. (Courtesy of Jean Meuwissen [c. 1900].)

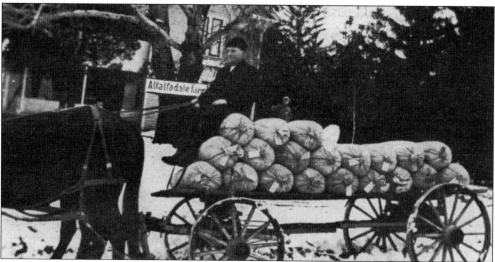

On October 4, 1913, Arthur B. Lyman registered his 257-acre farm in Chanhassen Township under the name Alfalfadale Farm. Grimm Alfalfa had been grown on the Lyman farm for many years. Arthur is seen here with wagon hitched and loaded with 20 sacks of Grimm Alfalfa being shipped to the US Department of Agriculture in Washington, DC, for which he was paid $2,160. (Courtesy of Jean Meuwissen [December 1912].)

German immigrant Wendelin Grimm brought 15 pounds of alfalfa seed from his homeland, planting it in the spring of 1858 on his Laketown Township farm. Like his father, Henry, Arthur B. Lyman had a deep interest in horticulture. In the early 1900s, he began promoting Grimm Alfalfa and pushed it to national recognition. Arthur had over 100 acres of alfalfa on his farm and marketed his seed as Lyman's Grimm Alfalfa Seed. (Courtesy of Jean Meuwissen.)

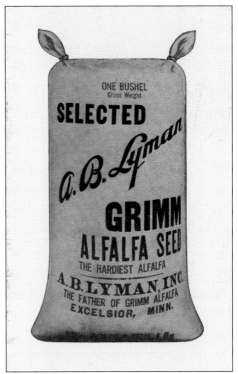

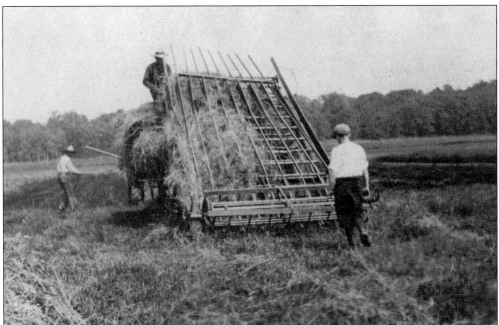

Laketown Township farmer Joseph Richter invented and patented a new and improved Combined Hay Rake and Loader in 1876. Hay loaders were designed for loading wagons with hay or straw, reducing the time and labor required to move it from field to wagon. Pictured here on the Francis Poppler farm in Laketown Township are Francis J. Poppler (on the hay wagon) and his son Richard (walking behind the hay loader). (Courtesy of Gerald & Geraldine Poppler [c. 1941].)

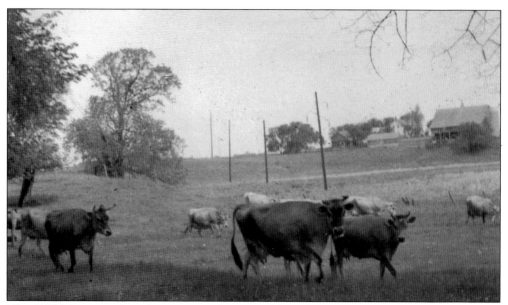

The 1909 Minnesota Legislature enacted a general law, Chapter 154, H.F. No. 568, providing for the registration of names of farms. On December 21, 1918, Benjamin F. Lemke registered his Benton Township farmland, comprising about 118 acres under the farm name The Sunny Hill Jersey Farm. A herd of his Jersey cattle are seen here grazing on farm pastureland. The Manteuffel farm near Winkler Lake is the neighboring farm seen in the background. (Courtesy of Fritz and Jane Widmer.)

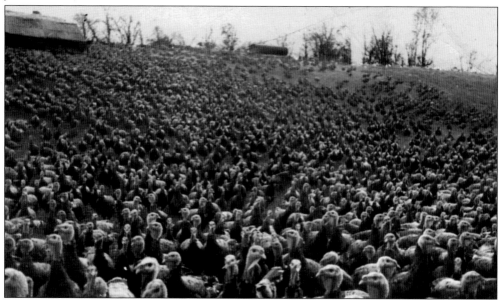

Richard Lyman and his brother Burt acquired turkey chicks, raised them on the Lyman farm in Chanhassen Township, and then sold them. Thousands of turkeys across Minnesota perished in the Armistice Day blizzard of November 11, 1940. One Lyman farm turkey sought shelter in a corn shock on a neighboring farm. The bird was discovered alive—but thin—three weeks later with its tail feathers frozen to the ground. Pictured here is a flock of 5,000 turkeys on the Lyman farm. (Courtesy of Jean Meuwissen.)

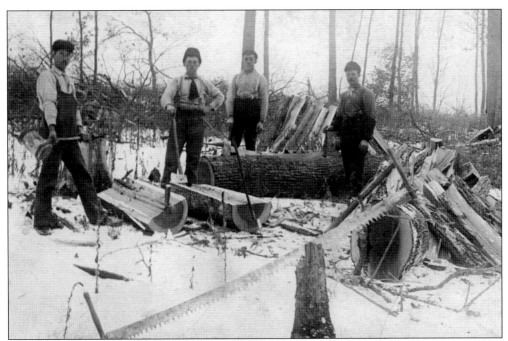

Waconia was heavily timbered with sugar maple and other hardwood trees. Cutting timber in this scene are, from left to right, George Koch hefting an iron-bound wooden mallet preparing to strike the metal wedge in the log in front of him, David Schmidt holding the handle of a felling axe, Eugene Kolb, and John Kunze. In the foreground is a two-man crosscut saw called the Tuttle Tooth. (Courtesy of Bonnie Riegert.)

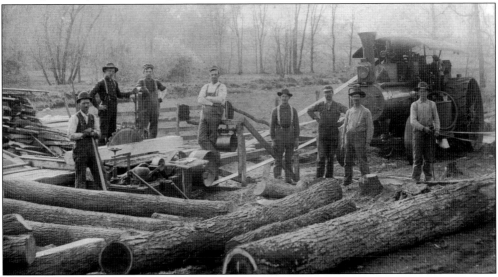

Prior to the 1880s, most sawmills were permanent operations powered by water. Then manufacturers producing threshers and steam engines added sawmills to their lines, which resulted in small sawmills flourishing. Farmers converted logs on their farms into lumber for buildings, fences, and repair work. Thresher Otto Quaas used his Reeves steam engine to power his sawmill at Mayer. Pictured from left to right are Otto Quaas, Chas. Quaas, Gust Hoeft, Ed Bergs, Geo. Grimm, Aron Pretzel, Henry Grimm Sr., and Henry Grimm Jr. (Courtesy of Alice Siewert [1915].)

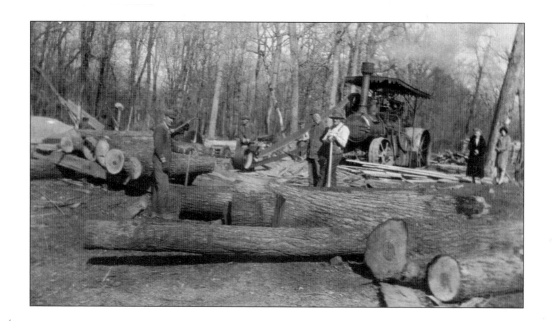

Timber was abundant on the Walter Biersdorf farm in Watertown Township. The timber needed to build a barn on his farm was cut from the trees on his land. Pictured above are Walter's father, Herman Beiersdorf (left), Glenn Beiersdorf (in white shirt), and Walter's mother, Ernestine "Tina" Beiersdorf (far right). A Buffalo Pitts steam engine stands at the ready to power the sawmill. On the left in the image below, two men are guiding a log through the saw, cutting it into boards for the barn construction. In the background on the left is a large pile of sawdust produced by the sawmill. (Both courtesy of Liz Beiersdorf [1929].)

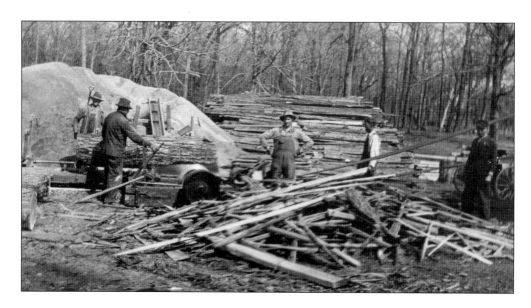

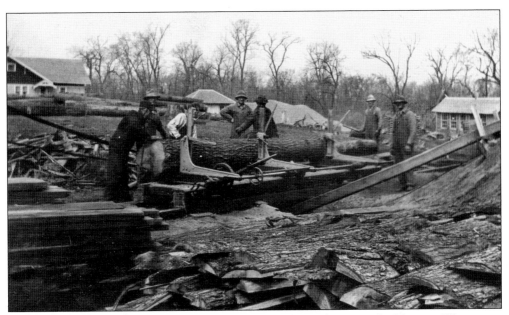

Sawing logs for lumber to construct a new barn on the Walter Biersdorf farm in Watertown Township continues in this image. The sawmill has been moved closer to the site of barn construction. The sawdust pile created earlier is seen in the center background. This sawmill has three head blocks to ease the job of setting the log. Mills of this type cut lumber in eight-foot or longer lengths. The farm home seen in the background on the left was built in 1920. (Courtesy of Liz Beiersdorf [1929].)

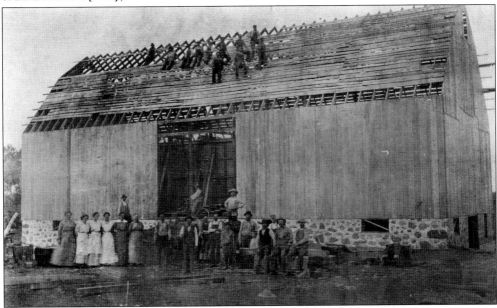

A barn raising in progress at the Carl Krey Jr. farm in Laketown Township shows the labor required for the job. To build a massive barn like the one pictured here would be a mammoth undertaking for a lone farmer. A barn raising was a combined work and social event that united neighbors and friends while tackling large farm tasks. Traditionally, the women prepared large meals throughout the day to feed the hungry workers. (Courtesy of Harriet and Ron Holtmeier [1914].)

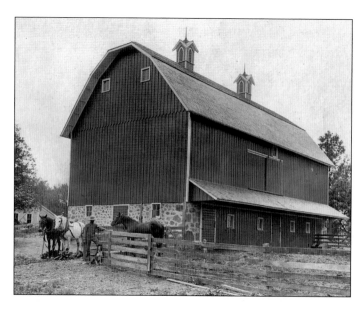

John Holtmeier Jr. stands in front of his barn on the pioneer farmstead in Laketown Township where he was born on April 21, 1862. He grew up farming alongside his father John Sr. and continued working the farm after his father's death on July 9, 1890. He was a charter member of the Victoria Creamery Association when it was organized in 1897. At the time, he had eight cows and paid $1 per cow to join the creamery association. (Courtesy of Harriet and Ron Holtmeier [c. 1920].)

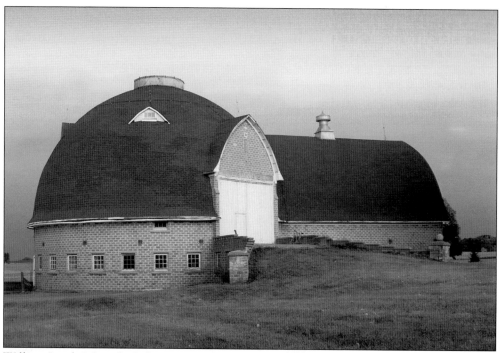

William Lemke's Lonely Oak Farm round barn is located in Benton Township and was built in 1927. Saffert Cement Construction Company designed the barn and supplied the Artstone block and tile for its construction. Materials were shipped by train and transported to the building site by horse-drawn wagons. The round portion of the barn features 36 stalls for milking and a 12-foot-diameter central silo for convenient feeding. The barn is currently owned by Loren and Kari Schwinghammer. (Ruth Tremblay [2009].)

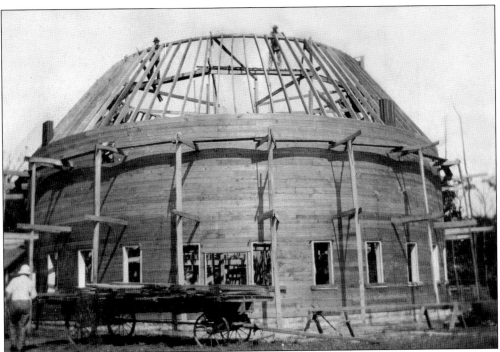

Benjamin Lemke's Sunny Hill Jersey Farm round barn is located in Benton Township and was built in 1919. It took one year to mill and prepare the lumber and a total of three years to build the barn. The one-inch planks were soaked in a nearby lake, affixed to a curved frame, and dried to create the bend in the lumber. The construction of the self-supporting roof is shown here. (Courtesy of Fritz and Jane Widmer [1919].)

Benjamin Lemke's Sunny Hill Jersey Farm round barn features a large-capacity haymow, lateral siding for greater wind resistance, and a deep, central interior silo constructed of solid redwood planks that measure over 50 feet high. His older brother William built a round barn on his farm in 1927, located less than six miles from Benjamin's barn. The farm is currently owned and well maintained by Fritz and Jane Widmer. (Ruth Tremblay [2008].)

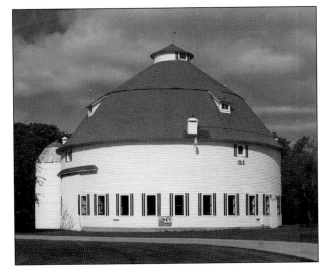

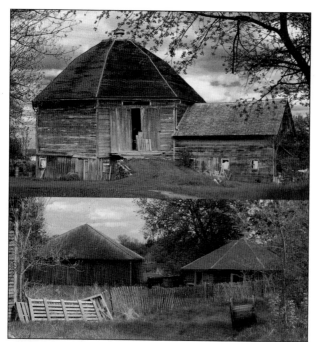

The Buckentine octagonal barns are located in Section 32 of Young America Township. The large, three-story octagonal barn was built in 1906 during the time that William Buckentine owned the farm. The barn features a stone foundation with an interior silo and a spacious haymow. There are two other smaller octagonal barns located on the southeast side of the main barn. The Buckentine family has owned the farm as far back as 1880. (Ruth Tremblay [2009].)

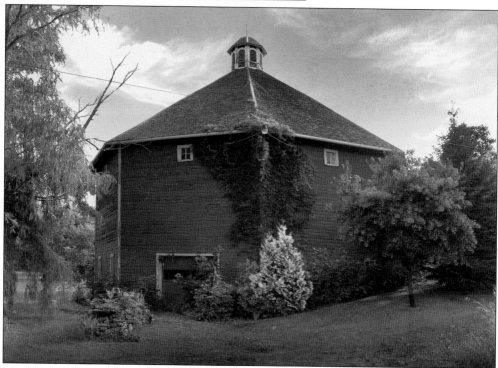

The Ketcher octagonal barn is located in Watertown Township near Swede Lake. Michael Ketcher (Kertzscher), an early pioneer, settled the farm in 1857. The eight-sided barn features a stone foundation and was built in 1906 when Louis Ketcher, Michael's son, owned the farm. Gerald Carlson currently owns the barn and takes great pride in preserving one of Carver County's historic treasures. (Ruth Tremblay [2008].)

Four

FAMILY LIFE AND LEISURE

Early settlers faced an enormous amount of work building shelter, clearing land, establishing food sources, caring for livestock, and obtaining a fuel supply for heat and cooking. Every able family member worked at tasks to establish their new home.

The first shelter established was often a temporary shanty to establish a claim and used while the settler worked to clear land and build a permanent dwelling. Log homes were common; some were a single room, while others were larger with perhaps an upper story or loft or a single story with multiple rooms. Early log buildings still exist on some Carver County farms. Wood frame homes and brick homes were also built during early settlement, and many of these are still in existence throughout the county.

Game was plentiful, and hunting supplied the family with fresh meat, such as venison, duck, and wild goose. Fish were also plentiful in all seasons in the more than 50 Carver County lakes and streams. In the spring and summer, berries of many kinds grew wild. Chokecherries grew in the woods, while strawberries were found in meadows and on creek banks. Along the edge of the woods, blackberries, raspberries, and gooseberries grew. Butternut trees were scattered in hilly areas, and hazelnut bushes grew at meadow's edge. The Big Woods was heavily timbered with sugar maples. Trees were tapped in the spring, and the sap was gathered in wooden buckets and boiled down into heavy syrup. Families relied on the preserved and stored foods they grew or gathered during the growing season to supply them until the next growing season. Meats were smoked, dried, or salt cured.

Being near water afforded settlers the opportunity to trap beaver and muskrat during the winter. They sold the pelts and earned a small income from the sale. The hides of larger animals were used for clothing items and as blankets for warmth.

There were many tasks that kept the women of the family busy. Some of the tasks included feeding the chickens, ducks, and geese and gathering the eggs; drawing water from the well to use in cooking, cleaning, and washing; spinning, sewing, and quilting; gardening and gathering nuts and berries; and making soap.

Neighbors helped neighbors with jobs that required a lot of manpower, dividing the workload to get the job done. Cutting timber, building a barn, threshing, and corn husking are examples of those jobs. Women provided large meals to fuel the workers, while children often helped by bringing water to the workers and fetching tools when needed. Not only did these gatherings get the job done, they gave everyone an opportunity to socialize and have some fun.

Despite the chores that children were required to do, they still had time for fun as well. Foot races, sledding, building snowmen, marbles, jacks, circle hoops, hopscotch, shadow tag, Red Rover,

and Ring Around the Rosie were favorite outdoor games and activities. Playing cards, checkers, dominos, jack straws, charades, and shadow puppets provided indoor fun. Family activities included visiting, picnics, birthdays and anniversary parties, fishing, swimming, sleigh rides, picking apples and berries, and gardening. Corn husk dolls and rag dolls, hand-carved wooden toys, and slingshots were a few of the simple playthings made from available materials.

In the late 1920s, Carver County began forming its first 4-H group. The purpose of the organization was to bridge the gap between public education and rural life. The goal was to give rural youths the opportunity to learn about new methods and ideas in agriculture through hands-on projects and experiments that they could share with the adults on the farm. Early 4-H activities included sewing, cooking, baking, canning, health education, and music and drama in addition to agriculture and livestock programs. In 1950, the emphasis was put on developing life, leadership, and citizenship skills.

Railroad travel and the county's numerous lakes appealed to those looking for a peaceful vacation. Boating, swimming, fishing, and steamboat excursions were just a few of the summertime activities enjoyed by the locals and visiting tourists. In 1886, the Lake Waconia Coney Island resort opened for business. The resort attracted an affluent group of people that arrived by train from the "Twin Cities" and traveled to the island by steamboat for a relaxing stay on the island. Between the late 1880s and early 1900s, the island's heyday, there were two hotels, a boardinghouse, several cottages, and a bathhouse on the island.

Sunday afternoon was a popular time to visit family, friends, or neighbors. Receiving visitors was a happy occasion, and it was customary if guests arrived at mealtime to invite them to share the family meal. Children played together while the adults socialized. The weekly newspaper often reported these visits and any out-of-town guests.

As travel became easier, there were more social activities. Picnics, baseball games, dances, fairs, parades, and festivals were just some of the social events common in the county. Social events were an opportunity for people to share news and to provide support, encouragement, and advice to one another.

In 1900, two fairs were held: one was the Carver County Fair at Carver, and the other was the Carver County Fair at Waconia. The fair at Carver ceased operation in the 1930s. The Carver County Fair continues to be held each year in August at the fairgrounds in Waconia and celebrated its 100th year in 2011.

Parades and festivals were held throughout the county in celebration of community milestones, holiday observances, and harvest time. These events abounded with food, fun, music, and contests. The Pioneer Maennerchor, a male German singing society in Young America, was formed in 1861. Stiftungsfest, or the Founders Day Festival, originated from this group. It is Minnesota's oldest annual celebration with 2011 marking the 150th year.

This chapter will take the reader from early homes and work to festivals and fun for all.

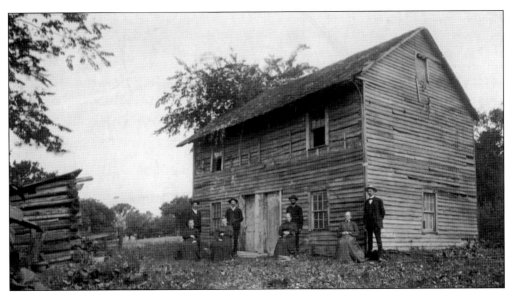

Built about 1854, this was the first two-story, two-family log dwelling in Carver County. It was the Laketown Township home of the John C. Holtmeier and Henry Gerdsen families. Pictured from left to right are (seated) Christina Fink (the second wife of Christ Fink, who had been married to sister Carrie before her death), Gisena Holtmeier, Mrs. C.H. (Mary) Fairchild, and Mrs. August (Anna) Lueck; (standing) Herman Holtmeier, William Holtmeier, John Holtmeier, and Sam Holtmeier. (Courtesy of Harriet and Ron Holtmeier [1908].)

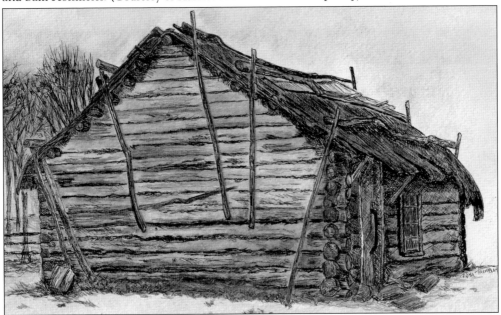

Andrew Peterson, an early Carver County settler, built this log shanty in August 1855 in Scandia, a Swedish settlement located on the southeast shore of Clearwater Lake in Laketown Township. He kept detailed diaries that chronicled his journey to America and his life in Carver County. In January 1888, he became an honorary lifetime member of the Minnesota Horticultural Society for his 25 years of experimentation and development of apples that resulted in many new winter-hardy varieties. (Illustration by Ruth Tremblay [2007].)

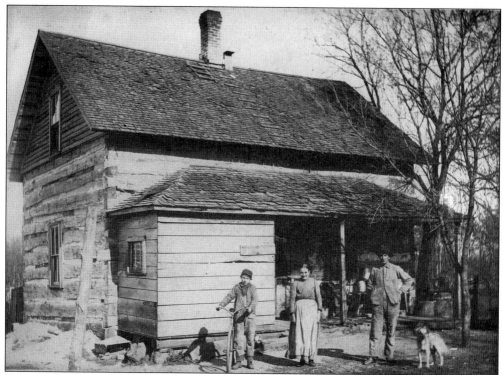

Herman Ehmke settled this Camden Township farm in 1886. At the 1991 Minnesota State Fair, the farm was honored as a Century Farm, which requires continuous ownership by the same family for a minimum of 100 years. In 2011, the farm celebrated its 125th year in the Ehmke family. In front of their log home are, from left to right, William Ehmke, Johanna (Salzwedel) Hoeft Ehmke (William and Gustav's mother), and Gustav Hoeft. (Courtesy of Olvern [Ehmke] Vinkemeier [c. 1906–1910].)

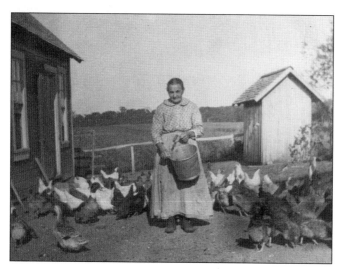

Johanna (Salzwedel) Hoeft arrived in America on June 2, 1892, at the Port of Baltimore (Maryland) from the Port of Bremen (Germany) with her husband Wilhelm Hoeft and their five children. Johanna's husband died two months after they arrived. On April 20, 1894, Herman Ehmke, a widower, married Johanna (Salzwedel) Hoeft. They had two children, William and Anna. Johanna is pictured here feeding the chickens. (Courtesy of Olvern [Ehmke] Vinkemeier [pre-1920].)

Wells were typically a circular shaft, three to four feet in diameter and up to 30 or 40 feet in depth. Early shafts were lined with stones or boards and later with Chaska brick fit in a circle of about 3.5 feet. Christina Swanson obtained water from her well in a small stave barrel with a handle using a hand crank and attached rope to raise and lower the barrel. (Courtesy of the Emma Anderson Mellgren family.)

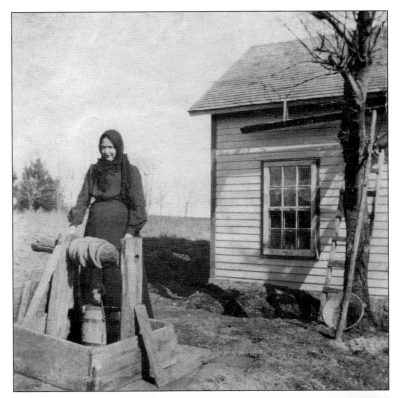

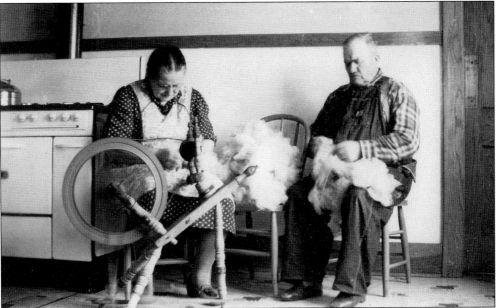

Frank and Augusta "Gustie" Bahr spin wool into yarn at their home in rural Watertown. The wool has been washed to remove the lanolin and "teased" and "carded," a series of combing steps that open the fibers. Frank is pulling the wool fibers into thin strips, a process called "roving," for Gustie to feed into the spinning wheel. The yarn is then collected on the spinning wheel's bobbin. (Courtesy of Olvern [Ehmke] Vinkemeier [c. 1940s].)

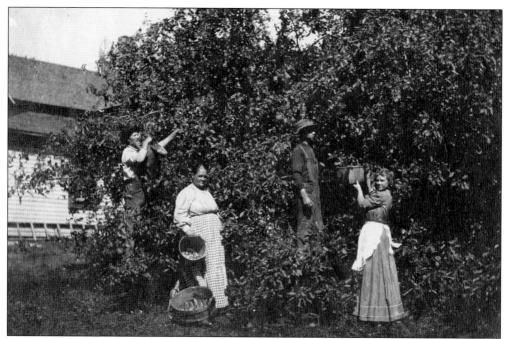

Apples were an important food source for families and were preserved for year-round consumption. Popular in many baking recipes, they were also made into fruit butters, preserves, and ciders. Pictured picking apples in San Francisco Township are Peter and Christina Felt with their children Victor and Josie. (Courtesy of the Emma Anderson Mellgren family.)

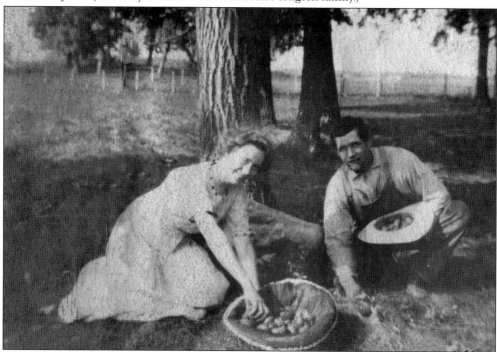

Benjamin and Clara (Thiele) Lemke enjoy an afternoon of picking nuts on the Sunnyhill Jersey Farm, their home in Benton Township. (Courtesy of Fritz and Jane Widmer [1913].)

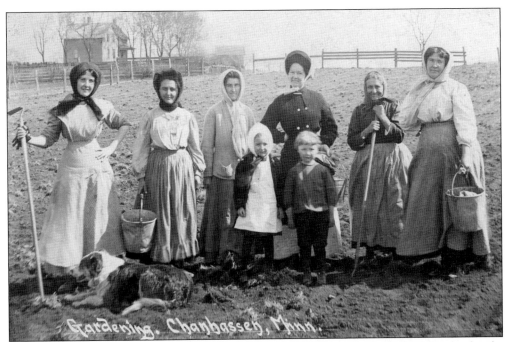

Gardens were planted and maintained by women and children to supply food for the family. Families had large gardens that provided fresh vegetables during the growing season and sufficient produce to preserve for use until the next growing season. Gardening in Chanhassen are, from left to right, Minnie Rosbach, Elizabeth (Schlenk) Rettler, Anna (Schlenk) Pauly, Rose (Geiser) Kelm, Mrs. Schlenk, and Anna (Rosbach) Schlenk; the children are Rosella Rettler and Martin Schlenk. (Authors' collection [1911].)

Working to bring in the harvest, this corn-husking crew enjoys a meal brought to the field. Often these meals were sandwiches and coffee. Corn was husked using a husking peg to more easily remove the husks. The cobs of corn were taken to the corncrib, a small slatted building, for storage. The dry corn stalks were often used for cattle fodder. Standing in front of the corn shocks, second from the left, is Lydia (Bergmann) Mueller. (Courtesy of the Fred Bergmann/Johann J. Mueller families.)

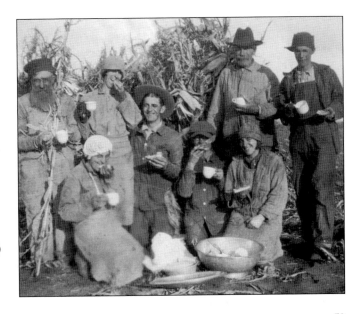

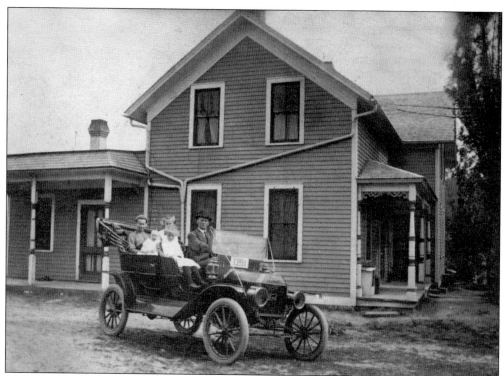

Frank A. Luetke is at the wheel of the family's Model T with daughter Cora next to him in the front seat on a visit to the Waconia Township farmhouse of Art Ziemer. In the back seat, from left to right, are Frank's wife Amanda, holding daughter Lucille, and daughter Edna. (Courtesy of the Luetke family [c. 1913–1915].)

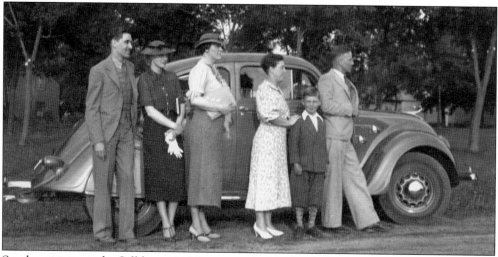

Sunday visitors at the Sell home in Mayer pose beside Gordon Volkenant's new 1936 Chrysler Airflow Coupe. The Airflow was the first streamlined American-made vehicle designed as a result of wind-tunnel testing. Manufactured from 1934 through 1937, this automobile made major contributions to the auto industry but was a commercial failure. Pictured from left to right are Gordon Volkenant, Mrs. Gordon Volkenant, unidentified, Hilda Sell, Charles Sell, and Elmer Sell. (Courtesy of Charles Sell [c. 1936].)

County Extension Homemakers Groups were part of the Agricultural Extension program of the University of Minnesota and administered by Minnesota county governments. Women were taught how to cook protein-rich meals using ration stamps during World War II, sewing, crafts, and new aspects of modern living. Learning proper skin care at a Carver County Extension Homemakers Group meeting are, from left to right, Verna Krause, Elsie Zieroth, Emma Luebke, and Marcella Kratzke. (Courtesy of the Luetke family [c. 1950s].)

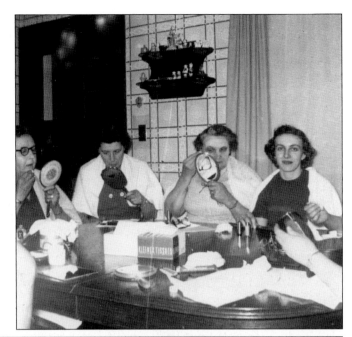

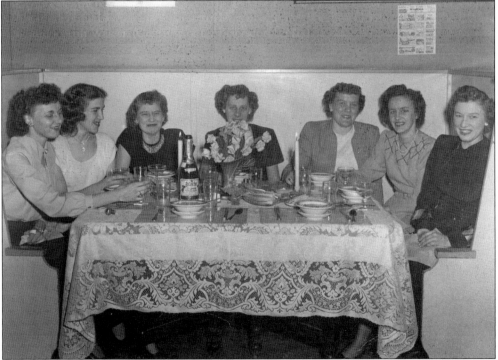

A group of young single ladies is celebrating a birthday at the Cozy Corner Cafe in Waconia. The restaurant was located on the northwest corner of Olive and Main Streets and was owned by Delores (Lano) Elling. Pictured from left to right are Jane (Doyle) Krueger, Rose Marie (Philippy) Sorenson, Katie Weinzierl, Margaret (Godfrey) Doyle, Marilyn (Allmann) Humphrey, June (Luhring) Miller, and Lorraine (Weinzierl) Heimkes. (Courtesy of Rose Marie [Philippy] Sorenson [February 1948].)

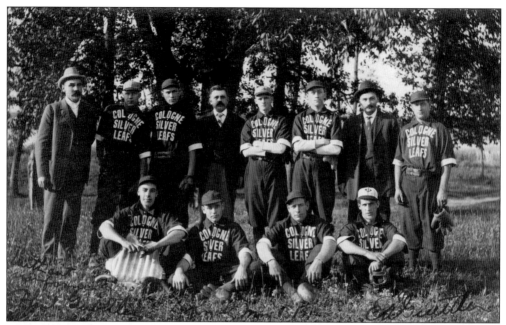

The Cologne Silver Leafs baseball team, sponsored by the Cologne Milling Company, was actively managed by Dr. John Knotz. He could be found every Sunday afternoon during baseball season at the local ballpark on Cologne's north side. Members of the team included Monty Hanson, Fischer, Brestrup, Claesgens, Wilson, Haus, Gehrig, E. Hanson, and Guetzke. (Courtesy of Marcia Tellers [1914].)

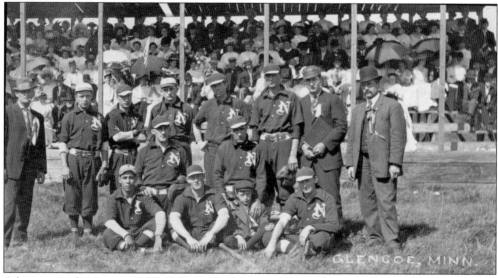

Admission to the August 22–23, 1908, baseball tournament in Glencoe was 35¢. Teams represented Norwood, Arlington, Plato, and Hutchinson, with the winner declared the champion; Norwood defeated Plato five to one for the title. Norwood team members seen here include Melander (shortstop), Canty (left field, pitcher), Anderson (center field), Billy Williams (right field, first base), McNamara (third base), Wetter (first base, right field), N. Morrison (second base), Asal (catcher), Jack Morrison (pitcher), Tucker (left field), Leif (catcher), and Bovy (right field). (Authors' collection [August 1908].)

Picnic. Mayer, Minn. Aug 14, '10.
- Fair Rooters at Ball Game. -

Foot races for men, as well as boys and girls, the long jump, hammer throw, tug-of-war, and a pie-eating contest were among the list of events featured at the Mayer Firemen's Picnic on August 14, 1910. A ball game between Lyndale and New Germany attracted this group of rooters. The teams played for a purse of $50. (Authors' collection [August 1910].)

Refreshment Stand. Picnic Mayer Minn. Aug 14, '10.

Described in the newspaper as a monster picnic at Scheidegger's Grove near Mayer, the Mayer Fire Department did everything possible to see that everyone in attendance had a rousing good time. In addition to the refreshment stand, the fire department band provided music for the August 14, 1910, event. Music for afternoon and evening dancing was provided by Raeder's Orchestra. (Courtesy of Liz Beiersdorf [August 1910].)

THE UNITED STATES OF AMERICA,

To all to whom these presents shall come, greeting:

This original land patent came to William H. Tilton through his purchase of 30 acres of public land in Section 8 of Chanhassen Township. He also acquired 120 acres in Sections 8 and 9 of the township in a Bounty Land Warrant from Catherine Hanson. Portions of these two land parcels were later part of a 62-acre farm owned by Gov. John Lind. On July 8, 1924, the Minneapolis Council of Camp Fire Girls purchased the 62-acre farm. This property on Lake Minnewashta became Camp Tanadoona. (Courtesy of Camp Fire USA Minnesota Council [July 1862].)

Campfire Girls Joanne Cory, Mary Jane Kistler, and Nancy Reid build a fireplace during a campfire activity at Camp Tanadoona located on Lake Minnewashta in Chanhassen Township. Since the camp's beginning in 1924, thousands of children have spent time there learning life skills, crafts, singing around the campfire, and swimming and participating in many other activities as part of the camp experience. (Courtesy of Camp Fire USA Minnesota Council [1939].)

In 1929, 4-H in Carver County was organized with four boys' and girls' clubs. George King and Mrs. Alvina Krause organized the Pleasant Valley 4-H Club in 1934 with 14 members. The club's initial mission was to help members improve themselves, their home, their community, and their club. Pictured here is a Pleasant Valley 4-H booth at the Carver County Fair. (Courtesy of the Luetke family [c. 1952].)

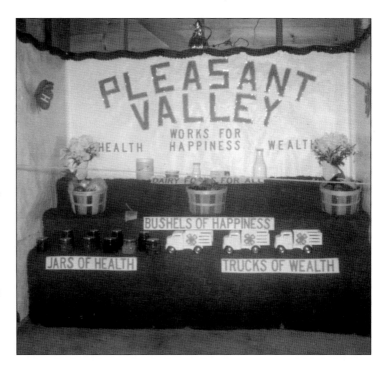

In addition to agriculture, livestock, and dairy projects, Pleasant Valley 4-H Club members participated in canning, home beautification, homemaking, bread baking, clowning, electricity projects, and music and play festivals. The club was nationally recognized for several years as the top 4-H club in America. Pictured here are, from left to right during a Pleasant Valley 4-H Club tour of the Zieroth farm in Waconia, Art Krause and Georgiana and Ed Zieroth. (Courtesy of the Luetke family [c. 1950].)

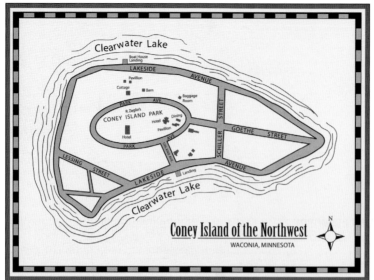

Coney Island is located in Clearwater Lake (Lake Waconia) about a half mile from its southwestern shore near downtown Waconia. The island is 1,500 feet east to west and 900 feet north to south, with a landmass of 31.85 acres. The island was laid out with 100 lots, a 6.35-acre centrally located park, and a street system. (Illustration by Ruth Tremblay [2011].)

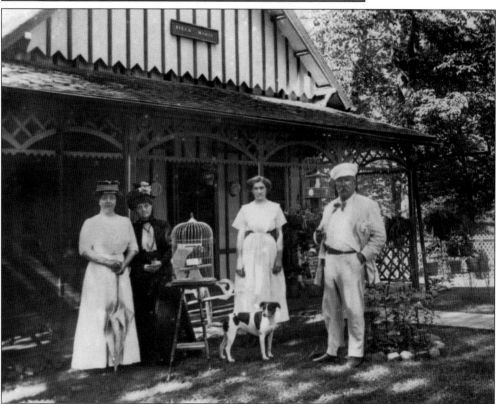

Having spent the summer of 1892 on Coney Island, Emile Amblard purchased part of the western side of the island in 1893. In 1894, he brought his wife, Mary Augusta, and her mother to the island. Villa Emile was the main cottage with Villa Marie used by Mary and her mother. Villa Topsy, a guest cottage, was named after Emile's dog Topsy. Pictured in front of Villa Marie are, from left to right, Mary Amblard, Mrs. Wood (Mary's mother), Lillian Osterfeld (Mary's companion), Topsy, and Emile Amblard. (Courtesy of Rose Marie [Philippy] Sorenson.)

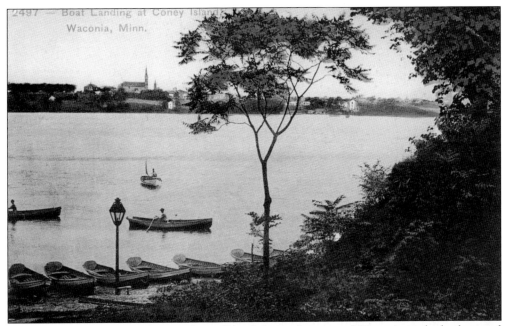

2497 — Boat Landing at Coney Island, Waconia, Minn.

A view from the Boat Landing on Coney Island shows the town of Waconia in the background with the steeple of St. Joseph's Catholic Church on the left. The rowboats lining the south shore of the island were available to the general public at the Weinzierl Boat Livery on the south shore of Lake Waconia. (Authors' collection [1915].)

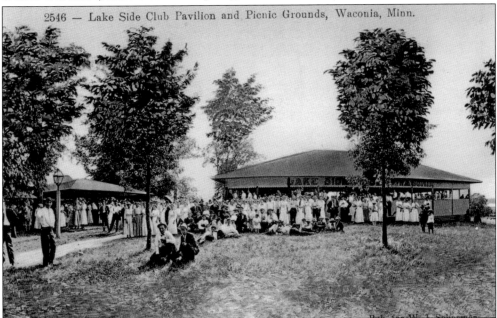

2546 — Lake Side Club Pavilion and Picnic Grounds, Waconia, Minn.

By 1911, the Lake Side Club Pavilion began serving the Waconia community. It was located between Walnut and Cedar Streets on a hill overlooking Lake Waconia. Sunday afternoon picnics, ball games, and evening dances were common activities held at the facility. A large crowd of picnickers is seen here at the Lake Side Club Pavilion. (Courtesy of the Kim Mackenthun family [c. 1915].)

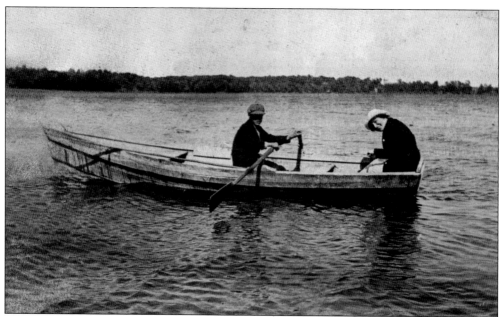

Francis (left) and Theresa "Daisy" Poppler enjoy a rowboat excursion on Piersons Lake, one of more than 50 lakes in Carver County. It is located in Laketown Township and was named for early Carver County settler John Pierson. Pierson, a Civil War veteran with the 5th Minnesota Infantry Regiment, immigrated to America in 1853 and began farming at the Piersons Lake site in 1855. Pierson died in 1900. (Courtesy of Gerald and Geraldine Poppler.)

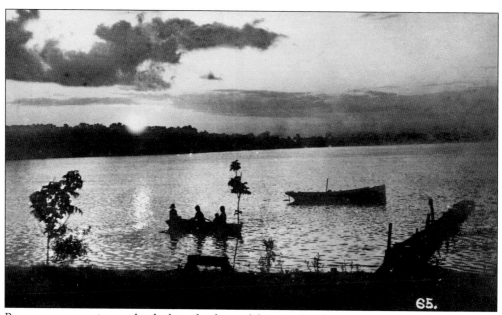

Boaters are returning to the dock in this beautiful view of Hydes Lake in Waconia Township. It is another of the more than 50 lakes in the county and covers approximately 222 acres. (Authors' collection [September 1907].)

For some crews, the end of the threshing season meant a large gathering with good food and a baseball game. For these hard-working farmers, it meant it was time to take their annual fishing trip to Lake Zumbra. Pictured from left to right are Waldo Jaekel, Albert Herrmann, and Jerry Flusemann. (Courtesy of Warren Flusemann [1930s or 1940s].)

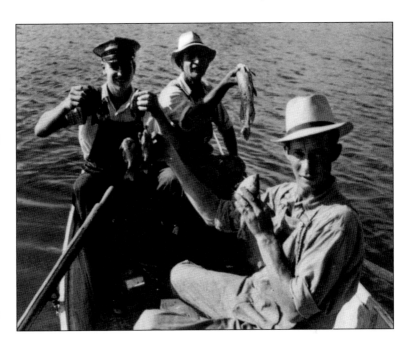

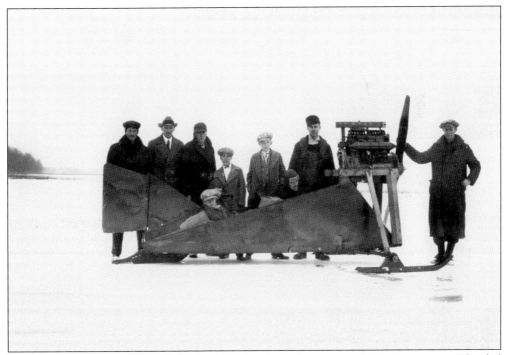

Elmer Sell sits in the pilot seat of his ice sled that he built using an old airplane motor. The sled reached a speed of approximately 70 miles per hour on its maiden voyage across Lake Waconia. He gave rides to the brave souls who did not mind that the sled was not equipped with brakes and required the use of a snow bank to slow the vehicle. (Courtesy of Charles Sell [c. 1928].)

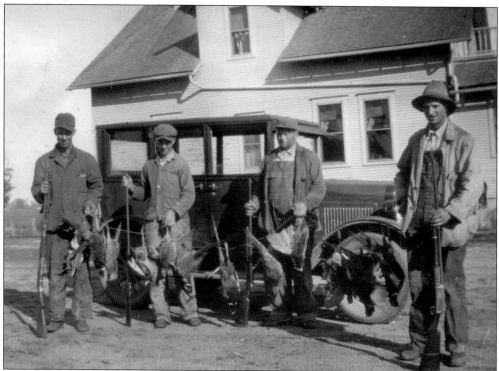

Hunting was not only a food source for families but provided men a chance for sport, socializing, and a welcome change from farm chores. Returning to the Roepke farm in New Germany from a successful day of hunting pheasants are Walter Roepke (far right) and his friends. (Courtesy of the David Effertz family.)

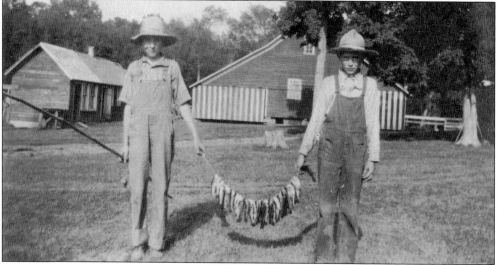

The Herman Beiersdorf farm was located near the South Fork of the Crow River, within easy walking distance for these young anglers. The Crow River and the lakes that are located in Watertown Township provided early residents with an important source for food as well as recreation. After a successful day of fishing, pictured with their catch are Walter (left) and Glenn Beiersdorf. (Courtesy of Liz Beiersdorf [c. 1915].)

Eleanor (Lenz) Magnuson (1913–2001) of Watertown enjoys the winter snow on her non-steerable, "clipper"-style wooden sled. The clipper, one of the earliest sled designs in America, originated around the 1850s and often featured a decorative design painted on its wooden deck. It was built low to the ground and featured long wooden sides with a thin metal runner and a rope to help the rider maintain balance. (Courtesy of Marlene Magnuson [c. 1918].)

Mrs. Ellen Olson's grandchildren share a cool "pop" in front of her lilac bushes on the family farm in Carver. The Olson's bottled milk under the name Ellendale Farm. Pictured on the left is Patricia (Olson) Probst, and on the right is her sister Evelyn Vivian (Olson) Ralston. (Courtesy of Patricia Probst [c. 1932].)

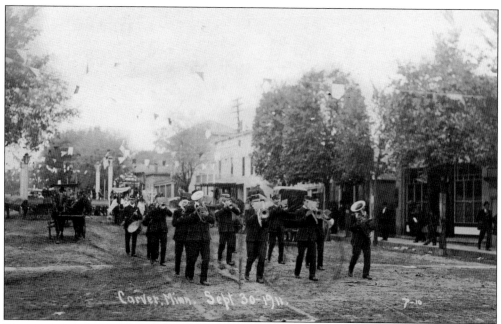

The streets are decorated with flags and bunting for the three days of the Carver County Fair at Carver, which began on Thursday, September 28. Several parades with floats and bands, band concerts, and the grand annual fair ball were just a few of the fair attractions. The fair was marred by two days of rain. This image is of one of the parades with a band marching south on Broadway toward the Minnesota River and Riverside Park. (Courtesy of John von Walter [1911].)

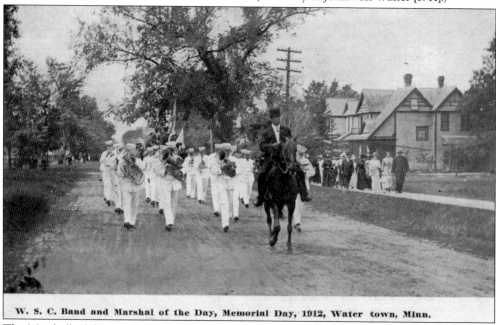

W. S. C. Band and Marshal of the Day, Memorial Day, 1912, Water town, Minn.

The Marshall of the Day leads the 1912 Watertown Memorial Day parade down Angel Avenue followed by the Watertown Silver Cornet Band. The band practiced all fall and winter to play at each cemetery on Memorial Day, civic functions, the midsummer picnic held at Trinity Lutheran Church, as well as march in the Delano Fourth of July parade. (Authors' collection [May 1912].)

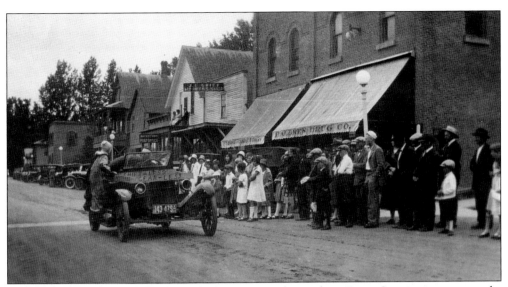

Residents of Watertown watch an "old jalopy" escort clowns down Lewis Street in a town parade. The structures beginning on the right are, from foreground to background, the Halgren Drug Co. store, the R.J. Burke Confectionery store, the J.E. Grife Harness Shop, and the post office. (Courtesy of Liz Beiersdorf [1924].)

The New Germany Corn Festival was an annual event sponsored by the New Germany Commercial Club that was held from 1948 to 1953. Farmers entered their best corn in a contest awarding prizes to the best five-cob displays. A costume contest was also held each year. Pictured here in a Corn Festival costume contest are Marcille Groenke (left) and Lillian Groenke. (Courtesy of the David Effertz family.)

The peony, an immensely popular perennial, has had hundreds of hybrids cultivated for centuries. Horticulturalist E.H. Lins of Cologne grew many prize-winning peonies on his Lins Glad Farm. Clipping blooms from a peony bush in their yard in Watertown Township are Ernestine "Tina" Beiersdorf with her sons Walter (left) and Glenn (right). (Courtesy of Liz Beiersdorf [c. 1915].)

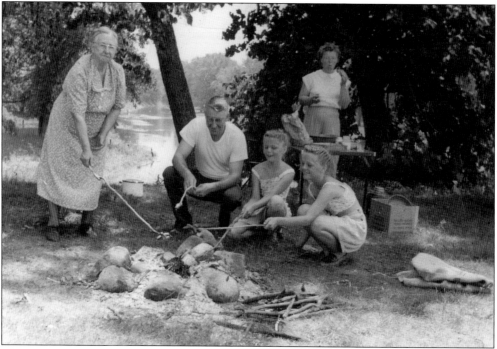

Three generations of a family are enjoying an old fashioned "wienie roast" on the west bank of the Crow River just north of the bridge in Watertown. In this photograph taken by Irene Menth (the sister of Louise Menth) are, from left to right, Lena Domras, Eddie Schmoldt, and twins Marilyn and Marlene Menth; in the background is Luella Menth. (Courtesy of Marlene Magnuson [1949].)

Five

CHURCHES AND SCHOOLS

Two years after Carver County opened to settlement, the population became large enough to begin the establishment of churches and schools. It is claimed that Susan Hazeltine established the first school in Carver County in Chanhassen Township in the fall of 1855 at the home of Arba Cleveland. A few weeks later, a permanent building was opened in Section 16. That winter, another school was founded in Carver with 25 students that was taught by George Bennett and held in the claim shanty of Axel Jorgenson, one of Carver's first settlers. Within two years, there were five school districts in Carver County with a total of 184 pupils. The accumulated school tax used by the districts was $787.64.

In the beginning, school attendance was not compulsory. The first compulsory school attendance law in Minnesota was enacted in 1885. The law required children ages 7 to 16 to attend school for 12 weeks each year. Requirements for public schools were outlined in the "Graded Course of Study for County Schools." Common school consisted of five grades, A through E, with A being the highest. In Grade E, a student studied reading, spelling, language, and numbers. Grade D had the same subjects but with more complex problems. Grade C added more complexity plus the addition of geography. Grade B added higher complexity to the previous subjects, and US and Minnesota history, government, and arithmetic were added to the course curriculum. For Grade A, the previous subjects were continued and orthography (the study of spelling), elements of bookkeeping, physiology, and hygiene were added courses. All grades were required to study writing and had general lessons that could include stories from history; current events; talks about animals, plants, or minerals; or simple experiments in chemistry and physics. In 1893, the adopted course of study for Chaska High School was three years. The curriculum in the first year was arithmetic, US history, grammar and composition, English, and American classics. The second year consisted of algebra, composition, and rhetoric for the full school year, while physiology, bookkeeping, and civics were for half of the year. The third year course of study was plane geometry, physics, English literature, and general history.

Parochial schools started appearing in Carver County around 1857. Many parents wanted to add religious studies to their children's educations. Since most of the churches originated along ethnic and religious lines, a parochial school could offer classes in a native language.

The first churches in Carver County were organized by the different ethnic groups settling in the county. Because of this, one might find the same type of Protestant or Catholic Church in close proximity, but the language spoken in church reflected the particular nationality of the settlers who started the church. It was well into the 20th century before the practice of having at least one service spoken in the original language of the congregation ended.

In the early days, church services were conducted in residents' homes by visiting ministers and priests from the surrounding counties. For example, the Benedictine's, Catholics from Shakopee, traveled to Carver and Chaska offering Mass and performing the sacraments. The Benedictines would record the sacraments they performed in the church books at St. Mark's in Shakopee. Reverend Black from Glencoe, a Methodist minister, would occasionally come to Carver and Chaska to preach. He was the first minister to preach in English.

Early Lutheran pastors, P.A. Cederstam, Prof. L.P. Esbjörn, Dr. E. Norelius, and Dr. T.N. Hasselquist, visited King Oscar's Settlement as early as 1855. The congregation formally organized as the Scandinavian Evangelical Lutheran, East Union Congregation in 1858. It is one of the oldest Lutheran churches in Minnesota and likely the oldest that has held services without interruption at the same location.

In June 1854, Rev. Charles Galpin, a Protestant, delivered the first sermon in Carver County at the home of Henry M. Lyman in Chanhassen Township. Thereafter, services were held every two weeks. When the weather cooperated, the service was held in a grove near Mr. Lyman's home.

Laketown Township was where the first Baptist church was founded in August 1855 at the home of Andrew Peterson. These first Baptists were Swedes, and their pastor was Rev. Frederick O. Nilsson. Reverend Nilsson conducted the first services in John Anderson's claim shanty on the eastern shore of Clearwater Lake (Lake Waconia). Nilsson was a traveling minister who mainly preached within Carver County and occasionally traveled outside of Minnesota.

One of Carver County's first Catholic parishes was St. Bernard's, organized in 1856 by Father Mehlmann in Benton Township. John Mohrbacher hosted services at his home until 1860, when a small frame church was built under the direction of Fr. Bruno Riss. The original church cost about $500. Benton Township also saw the first Methodist church in 1856. It was called Ebenezer Methodist Episcopal Church and formed by Rev. John Schnell with only six members.

The Moravian Church held their first regularly organized church service in Chaska on January 1, 1858. Brother Martin A. Erdmann conducted the services.

Soon after the establishment of churches, church groups and societies appeared. Known under names such as the Catholic Aid Society, the Sewing Society, and Ladies Aid, these organizations played an important role in the community. Not only did they provide a social environment for the participants, they also raised money for various projects within their churches and communities. Fundraising took many forms. A quilt would be made and raffled, or bake sales were sponsored. They were instrumental in providing funds for the various parochial schools, including erection of the buildings. Some of the societies required a monthly membership fee and entrance fees. Many times these groups were segregated by gender. The women's groups were called upon to provide a meal after a funeral or help with a sick or disabled member of the congregation.

This chapter will introduce the many churches with their varied architecture and schools, both public and parochial.

The beginning of West Union Lutheran Church in Hancock Township dates to August 13, 1858, when a meeting of people who desired to form a congregation to the west from the church at East Union, located six to eight miles distant, was held. On December 28, 1858, the congregation elected their deacons. In 1868, a new frame church 50 feet long, 18 feet wide, and 19 feet high was built. The steeple and bell were added in 1871, and in 1891 blinds were built to enclose the bell in the steeple. The image to the right shows the lapped siding of the exterior, the Gothic-style windows, and the enclosed bell tower. The image below is the earliest known photograph of the church interior. Decorated for Christmas, this view shows the central pulpit. (Both courtesy of the Emma Anderson Mellgren family [Below, 1893].)

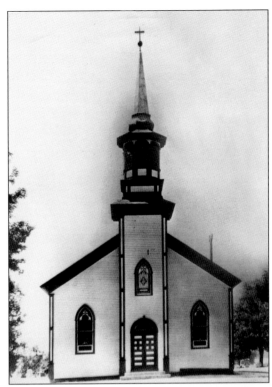

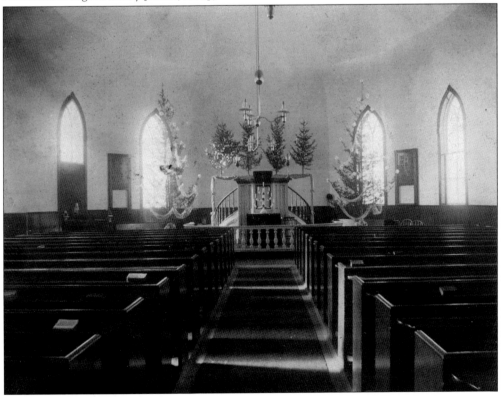

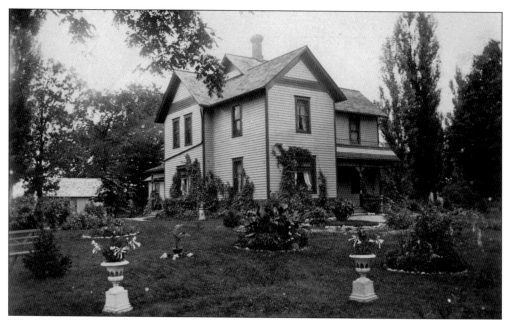

This West Union Lutheran Church parsonage was built in 1896 at a cost of $1,200. Over the years, this parsonage served as the home for eight pastors and their families. Many improvements were made to the house, including installation of a hot-water heating plant, a new chimney, new floors, new porches, and papering of the walls. On April 17, 1943, a fire destroyed the parsonage. (Courtesy of the Emma Anderson Mellgren family.)

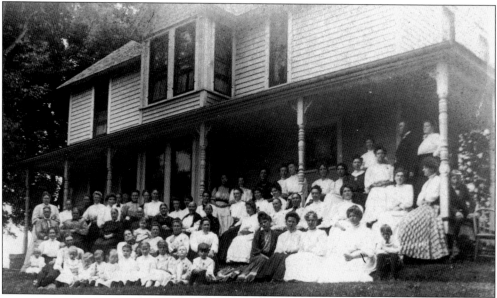

Organized about 1902, the West Union Lutheran Church Acorn Sewing Circle, consisting of young ladies of the congregation, funded many church improvements. Twice-monthly meetings were held in homes, and dues were 10¢. Until 1923, meetings were conducted in Swedish. By 1924, married women were admitted to the group. In 1932, the Acorn Sewing Circle was discontinued. The group is gathered on the porch of the Claes Johnson home for this photograph. (Courtesy of the Emma Anderson Mellgren family [c. 1924–1930].)

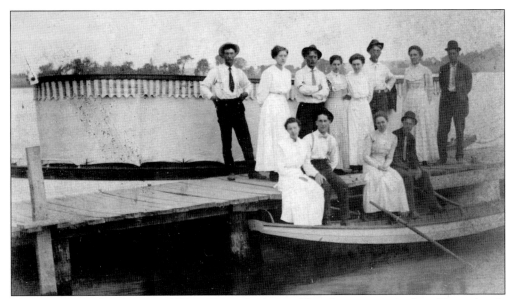

The Young People's Society of West Union Lutheran Church was organized on November 1, 1903. The purposes of the group were to advance the moral and spiritual life of its members, to foster a spirit of true Christian fellowship, and to promote an interest in the local church work. In 1919, the name was changed to the West Union Luther League. Members of the group are pictured here at an outing on Lake Waconia. (Courtesy of the Emma Anderson Mellgren family [c. early 1900s].)

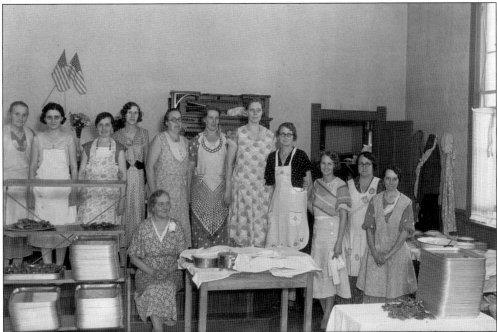

The kitchen crew for the 95th-anniversary celebration of West Union Lutheran Church in Hancock Township included Josephine Nelson, Emma Tengblad, Ella Tengblad, Ellen Berger, Viola Larson, Viola Olson, Emma Mellgren, Alice Almquist, Emma Anderson, Mayme Johnson, Ella Anderson, and Lillian Mellgren. (Courtesy of the Emma Anderson Mellgren family [1958].)

East Union Lutheran Church in Dahlgren Township was organized in 1858. Rev. Peter Carlson served the congregation from 1858 to 1880. In 1866, construction began on the church, taking two years to complete. It was built with Carver brick at a cost of $5,340. A new steeple was added to the front of the church in 1897 using Chaska brick. The Carver brick used for the main building was no longer available, making it impossible to match exactly the Chaska brick used for the steeple. (Lois Schulstad [2008].)

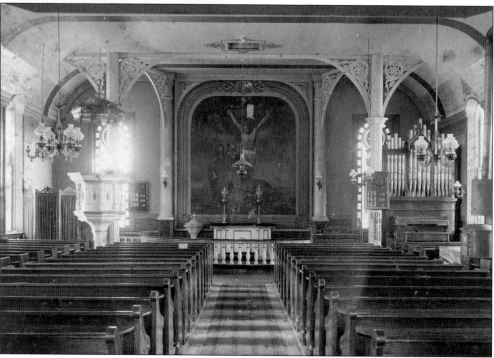

The altar picture in East Union Lutheran Church dates to 1886, and the two windows on either side are now in the church's Fellowship Hall. The janitor rang the bell in the bell tower, walked to the front of the church along wall on the right—past one of the wood stoves used to heat the church—and took his place behind the organ. Only after he began to pump the bellows on the pipe organ by hand could the organist begin to play music for the church service. (Courtesy of Vernis M. Strom [1908].)

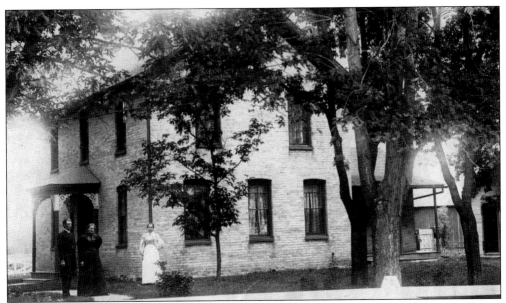

Built in 1874 at a cost of $1,540.74, the East Union Lutheran Church parsonage was constructed using Chaska brick. In the subsequent years, a windmill, porches, gaslights, electricity, a bathroom with running water, and a furnace were added. Pictured from left to right in front of the parsonage are Pastor and Mrs. Carl J. Edman and an unidentified female. Pastor Edman served the congregation from 1891 to 1902. (Courtesy of East Union Lutheran Church [c. 1900].)

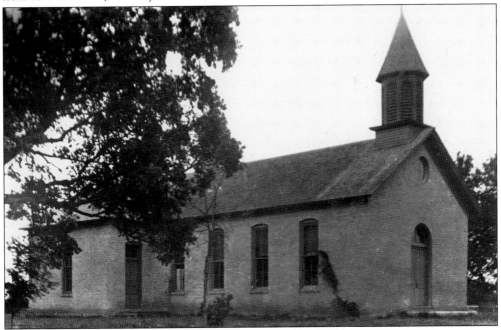

In February 1892, the trustees of School District 21 sought bids for the building of a schoolhouse veneered with brick, measuring 24 feet wide by 40 feet long and 14 feet in height. The building was completed in the summer of 1892. In September 1906, work was completed on an additional room built onto the school. Eight grades were taught by two teachers at the East Union School. (Courtesy of Scott Hallin.)

Catholic Church, Chaska, Minn.

In 1858, a group of Catholic families from Chaska and the surrounding area, along with the Benedictine Fathers, decided the Chaska area could support a church. Guardian Angels Catholic Church got its name after two-year-old Margaret Guenser, when asked to choose the picture she liked best from a handful of religious pictures, chose the one of a guardian angel. It is uncertain when the first church building was erected. The new church built in 1885 was gutted by a fire in 1902. The church was rebuilt and rededicated exactly one year later on October 7, 1903. In 1869, the church purchased the John Goetz property, converting a house on the property into a school. In 1880, a new school was built across the street from the church. The school closed in 1973. The image to the left is Guardian Angels Catholic Church. The image below is Guardian Angels Catholic School. (At left, courtesy of Marcia Tellers [1937]; below, authors' collection [1918].)

GUARDIAN ANGELS SCHOOL, CHASKA, MINN.

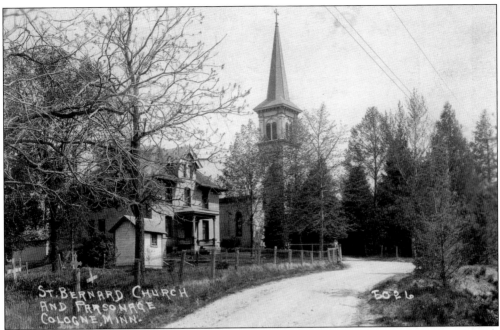

St. Bernard Catholic Church in Cologne was a mission church until 1876 when the first resident priest, Fr. Gottfried Braun, arrived. First services were held in 1856, and the first baptism was recorded in 1859. A small frame church was built in 1860 for $500. The church in the image above was constructed in 1877 for $14,000. The first St. Bernard Catholic School was built in 1880 and was a combined convent and school. Peter Wirtz was the school's first teacher. In 1881, the school was staffed by the School Sisters of Notre Dame. A new school was constructed in 1915 at a cost of nearly $50,000 for the building and furnishings. A new convent was built for the School Sisters of Notre Dame in 1952. The image above is of St. Bernard Catholic Church and Parsonage. The image below is of St. Bernard Catholic School and Convent. (Both courtesy of Marcia Tellers; above, 1927; below, 1909].)

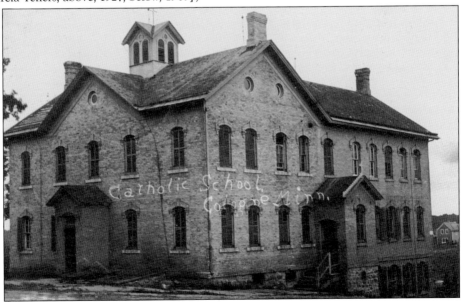

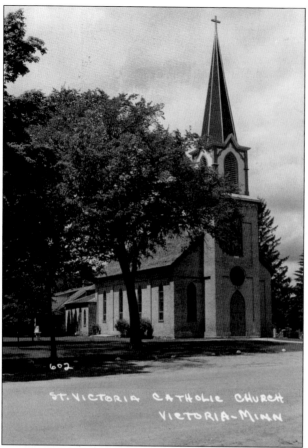

It is believed that the St. Victoria Catholic Parish was organized about 1856. The parish was visited periodically by the Benedictine Fathers from Scott County. A log church building was constructed in 1858. By 1863, the little log church was overcrowded, and more settlers continued to arrive in the area, compounding the situation. The members of the parish agreed that a larger church was needed, but funds were scarce to build with materials other than logs. The image to the left is of the St. Victoria Catholic Church brick structure, erected in 1870 replacing the little log church. The steeple was added in 1884. The image below is of the interior of the church with the beautiful main altar and two side altars that were built and installed about 1890. In 1953, the interior was remodeled and the side altars were removed. (At left, courtesy of Marcia Tellers; below, Harriet and Ron Holtmeier [c. 1916].)

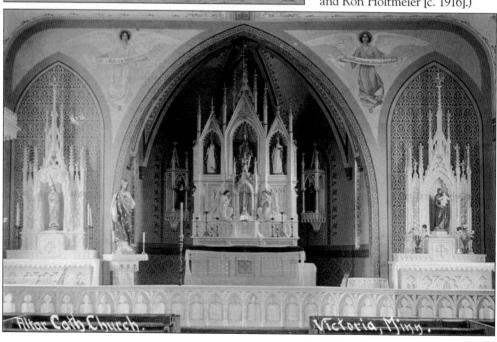

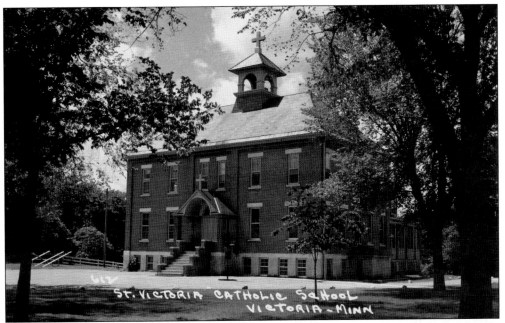

The St. Victoria Catholic Parish in Victoria built a school at the same time it built the log church. A two-story frame school building was erected in 1875. Pictured is the third St. Victoria Catholic School building. The school closed in 1917. (Courtesy of Marcia Tellers.)

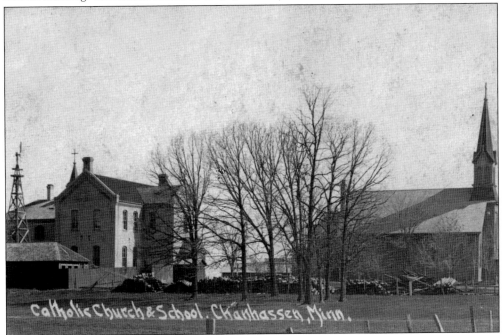

St. Hubert Catholic Church in Chanhassen began with a small log chapel built in 1865. In 1873, a small frame church was constructed with an attached two-room rectory. In 1887, a new church was erected at a cost of $6,400 and dedicated in the fall of 1888. St. Hubert Catholic School was built in 1881 and replaced in 1894; it was torn down in 1974. On the left in this image is the school, and on the right is the church. (Courtesy of Theresa Spande.)

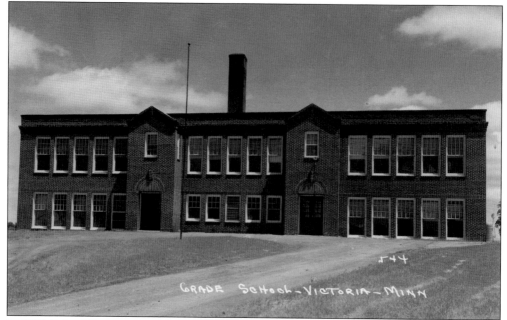

In 1919, School District 54 consolidated with School Districts 11 and 16. A large brick building was constructed in Victoria at a cost of about $40,000. Pictured is the Victoria Grade School. (Courtesy of Harriet and Ron Holtmeier.)

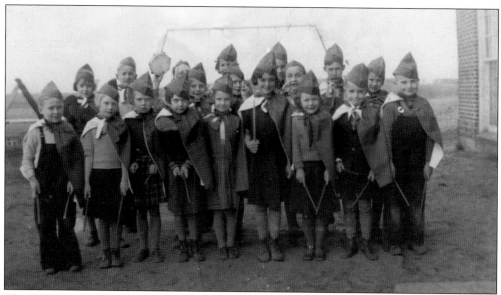

The 1937 Victoria Elementary School Rhythm Band members pictured here are, from left to right, (front row) Neil Nordberg, Marjory Goldschmidt, Louise Kaufold, Helen Wolff, Virginia Thurk, Lillian Goldschmidt, Gertrude Walter, Ron Holtmeier, and unidentified; (middle row) Juanne Rippel, MaryJane Wolff, Jean Rippel, and Robert Spoener; (back row) Lorna Gast, Clarence Gast, unidentified, Dorothy Braunworth, Richard Kroening, Kenneth Schulz, and LaDora Boley. (Courtesy of Harriet and Ron Holtmeier [March 1937].)

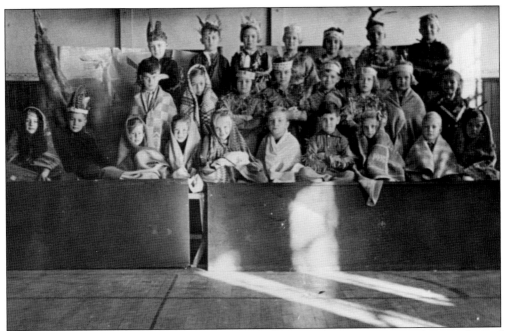

In 1937, the students of Victoria Elementary School performed the play *Hiawatha*. Members of the cast pictured here are, from left to right, (front row) Marlene Dummer, Ron Holtmeier, Adele Batzli, Marlene Kaufold, Pauline Huff, Leroy Schneewind, Jim Fink, Marion Plocher, Wayne Dummer, and unidentified; (middle row) Harold Kunz, Ruth Kroening, Marjorie Boley, Helen Wolff, William Kaufold, Marie Batzli, Mr. Wallin, and unidentified; (back row) Neil Bielka, Gene Albert, Louise Kaufold, Marjory Goldschmidt, Jeanne Plocher, Donald Drew, and Robert Spoener. (Courtesy of Harriet and Ron Holtmeier [1937].)

The students at Sunnyside School, District No. 35 are posing for this photograph outside the schoolhouse. Pictured from left to right are (front row) Roland Krumsieg, Henrietta Beiersdorf, Eva Lindstrom, Lenore Akins, Viola Tesch, Henry Bahr, and Edwin Bahr; (middle row) Carl Lindstrom, Glenn Beiersdorf, Verda Fillbrandt, Mabel Monson, Trieda Beiersdorf, Tillie Tesch, Othelia Lindstrom, and Lucille Fillbrandt; (back row) Erwin Thies, Clarence Tesch, teacher Miss Wilcot, Myrtle Lindstrom, Tillie Krumsieg, and Emma Beiersdorf. (Courtesy of Liz Beiersdorf [May 1917].)

2531 – German Lutheran Church, Waconia, Minn.

Pub. for W. J. Scharmer

On October 8, 1865, Trinity Lutheran Church in Waconia organized with 20 families. Built in the Gothic style and dedicated in 1890, this the second church building measured 46 feet by 72 feet and 36 feet in height at the center with a 116-foot bell tower. This view shows the completed building constructed using solid Chaska cream brick, Kasota sandstone coping and trimmings, and field granite foundation walls four to five feet thick. (Courtesy of the Kim Mackenthun family [c. 1910].)

Motorized hearses appeared in the first decade of the 20th century. They were often owned by the town livery and rented for funerals. Acceptance was slow; many people felt it just was not dignified for a funeral procession to move at such a fast pace. Justus Krause was born on November 28, 1842, in Germany. His funeral was held at his home on June 10, 1921. Charles F. Uecker was the undertaker. This hearse was used to transport his remains for burial in the Trinity Lutheran Church Cemetery in Waconia. (Courtesy of Liz Beiersdorf [1921].)

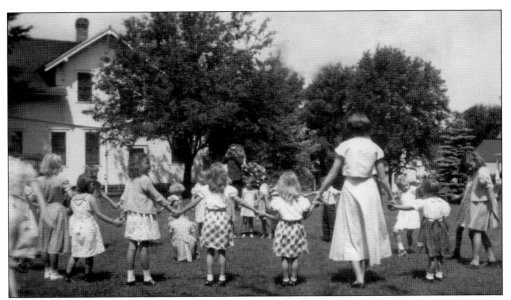

Children and teachers are playing Red Rover during recess at Trinity Lutheran School in Waconia. The popular game had its origins in the 1800s. As the game got underway, players would be heard shouting "Red Rover, Red Rover, let [name of player of opposing team] come over." (Courtesy of the Luetke family [c. 1943].)

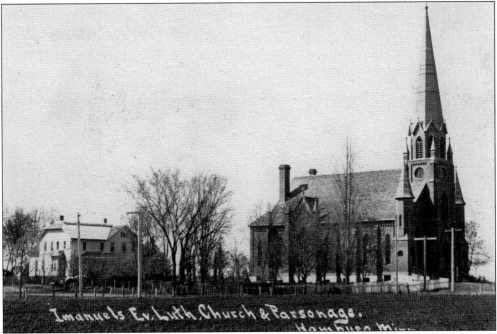

In 1857, a missionary named Rev. Friedrich Kahmeyer traveled to the area. The Evangelical Lutheran Immanuel's Congregation in Hamburg adopted its constitution and elected its first elders on April 21, 1861. This view of the church shows the solid brick structure measuring 56 feet wide and 103 feet long with a 140-foot steeple. Dedicated on November 12, 1899, it was completed at a cost of $20,000. The parsonage was built in 1878. (Courtesy of the Fred Bergmann/Johann J. Mueller families.)

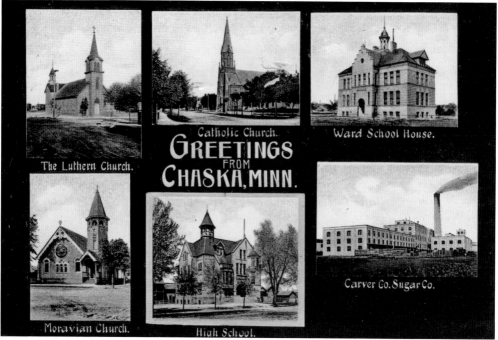

Catholic Church.

GREETINGS FROM CHASKA, MINN.

The Luthern Church.

Ward School House.

Moravian Church.

High School.

Carver Co. Sugar Co.

St. John's Lutheran Church, in the upper left, was built and dedicated November 1, 1885. This church building burned to the ground on August 23, 1921. Above center is Guardian Angels Catholic Church, and in the upper right is Chaska Ward School. The Moravian Church of Chaska, in the lower left, was built in 1889. The church was established in 1858 with a number of members coming to Carver County from the Moravian church at Hopedale, Pennsylvania. Chaska High School, seen below center, later became city hall. Pictured in the lower right is Carver County Sugar Company. (Authors' collection [1911].)

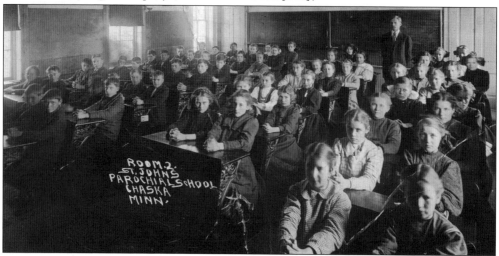

The church served as the school from 1886 to 1892. On February 12, 1892, the two-story St. John's Lutheran Church Parochial School was dedicated. The school had two classrooms. Enrollment necessitated two teachers; however, during the period from 1892 to 1920 there were several years the congregation had only one teacher. This image is of Room 2, a classroom filled with nearly 50 students and one teacher. (Courtesy of Liz Beiersdorf.)

The Church of the Ascension in Norwood is of Gothic-style architecture. Work on the church began in the spring of 1905. The cornerstone was laid on May 10 of that year. A tin box containing a few church records, copies of area newspapers, and a list of names of those who contributed toward the building fund was placed in the stone and cemented in the wall. Some difficulty in procuring materials and laborers arose during construction. On November 15, 1905, the new church was dedicated. (Authors' collection [1908].)

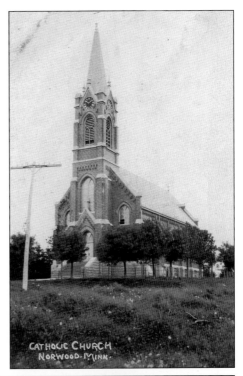

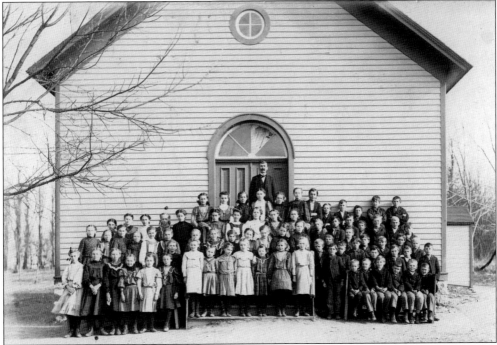

The Zion Lutheran Church School in Benton Township was built in 1887. By 1902, a wall had been removed and the school became one room. At times, upwards of 90 children were in attendance. Pictured in suit and tie is William Gierke, who was a teacher in the school from 1900 to 1916. (Courtesy of Olvern [Ehmke] Vinkemeier [c. 1907–1908].)

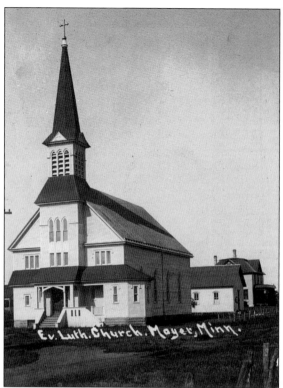

Zion Lutheran Church in Mayer originated in Helvetia, one mile to the north. When the railroads came through the area, Mayer and the population in the surrounding area grew, driving the need for a larger church. After much discussion, it was decided in 1904 to build a new church in Mayer at a cost of $10,000. It was constructed, and the dedication was on November 5, 1905. (Courtesy of Liz Beiersdorf.)

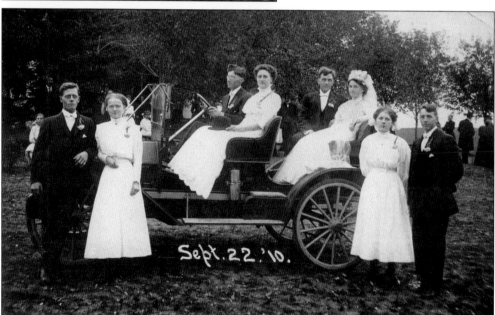

Happily wedded at Trinity Lutheran Church in Waconia on September 22, 1910, this bride and groom are pausing before being taken for a spin. Members of the bridal party posing include, from left to right, Phillip Schmidt, Martha Hill, Albert Hill (behind the wheel), Louise Kloos, Ferdinand Schmidt (groom), Elizabeth Hill (bride), Lydia Schmidt, and Henry Hill. (Courtesy of Liz Beiersdorf [September 1910].)

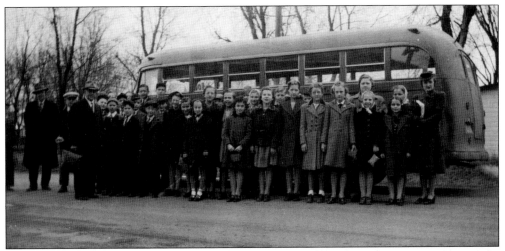

Schoolchildren from Zion Lutheran School in Mayer are pictured on a bus trip to Minneapolis to sing on KSTP radio. The group includes, from left to right, (front row) teacher Emil Ernst, Walner Dietzel, Milton Vollrath, Merlyn Boettcher, Arlene Ortloff, Darlene Biersdorf, Lois Hill, Lois Gongoll, Lorraine Barlau, Gladys Munkelwitz, Norma Schuette, Irene Stender, Phyllis Hoese, Marceline Fairchild, and Dorothy Krueger; (back row) Elmer Schwandt, Delbert Schuette, two unidentified, Alvin Vollrath, unidentified, Norville Luebke, Martin Rolf, Ardell Barlau, Viona Kohls, unidentified, Loren Splettstoeszer, Renata Schwandt, Gordon Grimm, unidentified, Paula Rolf, and JoAnn Wasser. (Courtesy of Liz Beiersdorf [1942].)

CATHOLIC IMMACULATE CONCEPTION CHURCH. SWEDISH LUTHERAN CHURCH.
WATERTOWN, MINN.

Two Watertown churches are pictured here. On the left is the Church of the Immaculate Conception. Constructed in 1876, it was the second church building of the parish. The bell was made by the McShane Bell Foundry in Baltimore, Maryland, and engraved with the date "Dec. 8, 1883." On the right is Götaholm. Constructed in 1890, this is the third church building. A fire on June 7, 1948, destroyed records and the building. In 1949, after the church was rebuilt, it was named Trinity Lutheran Church. (Authors' collection.)

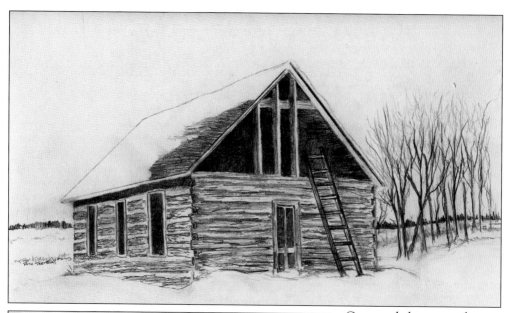

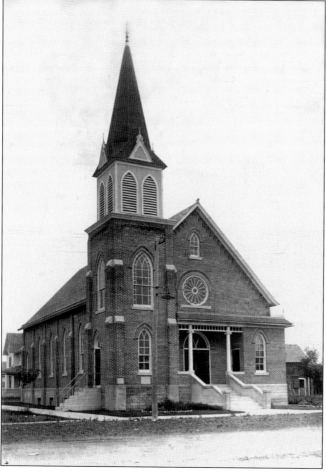

Commonly known as the Crow River Church or the Old Log Church, St. Paul's Evangelical Lutheran Church was located two and a half miles southeast of New Germany. The log church in the illustration above was erected about 1883 on an acre of farmland belonging to Ferdinand Henning. A portion of the land was used for a cemetery. At left is St. Mark's Evangelical Lutheran Church, built in New Germany in 1914. The St. Paul's congregation dissolved, and some members went to a church in Mayer, while others became members of St. Mark's in New Germany. A few years later, the Old Log Church was dismantled, and the logs were sold for $1 each. (Above, Illustration by Ruth Tremblay [2011]; at left, courtesy of the David Effertz family [1914].)

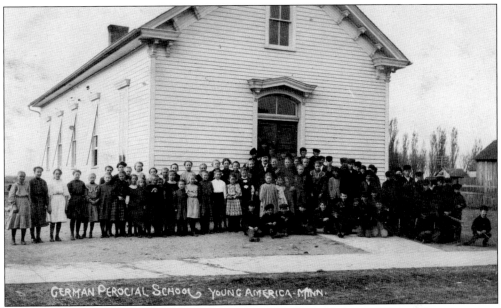

Dedicated on October 14, 1883, the new St. John's Lutheran School of Young America was a German parochial school built on a plot of land purchased for $100 by the congregation in 1879. The frame building measured 24 feet wide, 40 feet long, and 14 feet high. An 1890 epidemic of croup and diphtheria claimed the lives of 30 children. Standing in the center, wearing a suit, tie, and hat, is Theodore Buegel, who served as teacher from 1890 to 1932. (Courtesy of Marcia Tellers.)

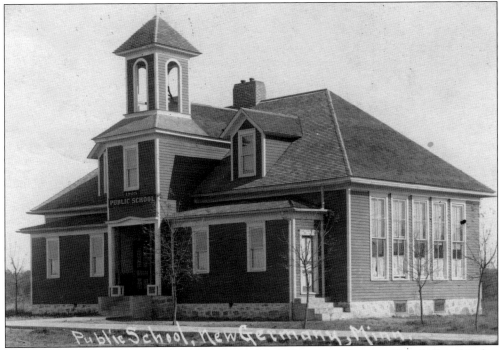

In 1908, School District No. 77 was organized at New Germany. Margaret Campbell and Esther O'Dell were the first teachers. Pictured is the New Germany Public School, built in 1908. (Authors' collection [1910].)

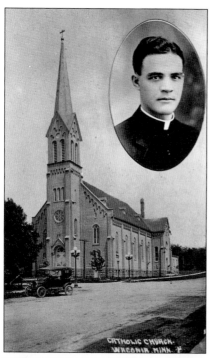

On March 14, 1858, a group of Catholics who began celebrating mass in a temporary church in 1857 decided to build a church and name it St. Joseph Catholic Church; it was to be located in Waconia. By 1900, membership had increased once again, requiring the building of their third church. This image shows the church, built in the Romanesque style, at 160 feet long, 72 feet at the transepts, and a 150-foot-high steeple. It is located at the corner of Elm and First Streets. (Courtesy of Bonnie Riegert [c. 1900].)

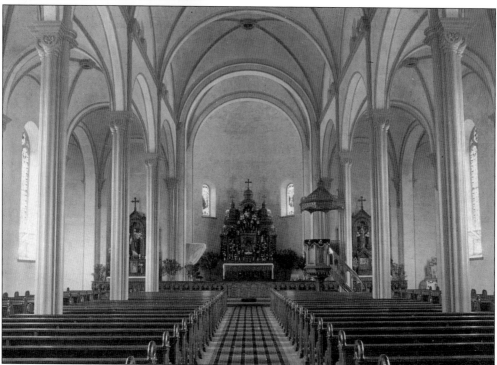

The main altar of St. Joseph Catholic Church in Waconia is Romanesque style and made of butternut wood. The many church objects and art are of Franciscan influence. The interior of the church had some remodeling in 1989. For a Baroque Romanesque touch, the walls and ceilings were repainted with new gold leaf. (Courtesy of Bonnie Riegert.)

By 1908, St. Joseph Catholic School in Waconia had grown to an enrollment of 180 pupils. A new building was urgently needed. On the left in this image is the large brick school, and on the right is the convent. Both were built in 1908. (Authors' collection [1942].)

The Moravian Brethren's Church of Laketown erected a simple Gothic building of Chaska brick in 1878 near Lake Auburn. Pictured is the Laketown Moravian Church in Victoria, with Rev. Theophilus Martin on the left. (Courtesy of Harriet and Ron Holtmeier [c. 1908–1912].)

In the 1870s, few families in Carver had need of horses, and this caused difficulty getting to and from church in East Union, the nearest Swedish congregation. As a result, the Swedish people living in and around Carver obtained approval to build a frame church in 1876. Named Salem Lutheran Church, it is pictured here with its tall steeple. A pastor was shared with the East Union congregation until December 1890. The congregation dissolved on January 24, 1952. (Courtesy of East Union Lutheran Church.)

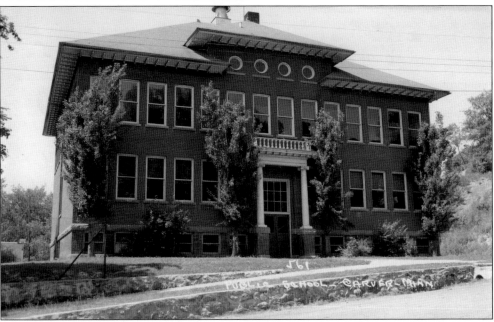

Carver School was Minnesota School District No. 1 for more than 100 years. Built in 1908, it served as Carver High School until the Depression and was closed in 1970. This image depicts the two-and-a-half-story redbrick Carver School. (Courtesy of John von Walter [1953 or before].)

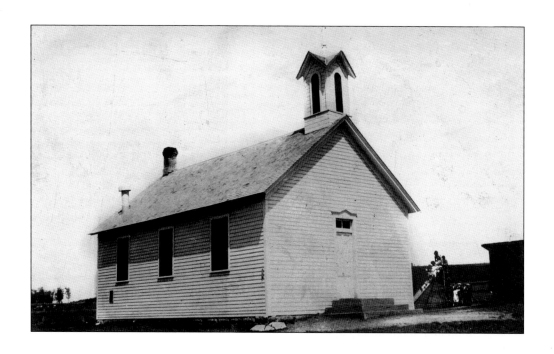

School District 34 in Watertown Township was known as Pleasant Valley School. The "Treasurer's Book of Records" for the school year 1900–1901 shows that the salary for the teacher ranged from $28 to $34 per month. In the background of the image above, students are at recess playing on the teeter-totters and slide. In the image below, students are balancing on the teeter-totters on the same playground. (Both courtesy of the Luetke family.)

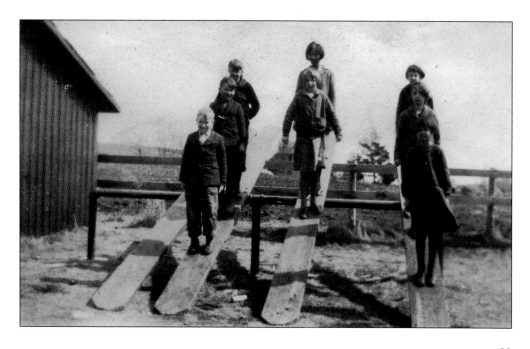

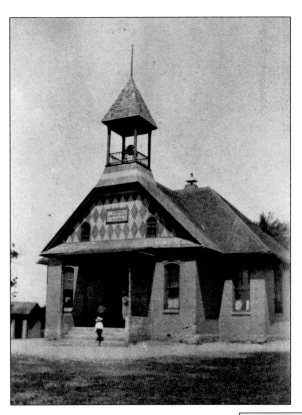

School District No. 16 in Laketown Township was also known as the Gerdsen District. The school was located at what is now the entrance to Carver Park. Seen here is the two-room, brick-veneered District No. 16 School, built in 1894. The building was demolished in 1924, and the wood from the school was used to construct a house on Victoria Drive in Victoria. (Courtesy of Harriet and Ron Holtmeier [1912].)

The report card covers for Carver County Schools in 1924 were furnished courtesy of First National Bank in Chaska. The covers included a message from the bank to start a savings account with as little as $1. The report card included attendance, examination results, and standings of the pupil. This image is a composite view of the cover and the report card that was enclosed in it. (Courtesy of the Susanna Danielson Thilquist collection [1924].)

Six

TRANSPORTATION AND COMMUNICATION

When Carver County opened for settlement in 1853, travel was a challenge. Many settlers walked or traveled very slowly with an oxen-pulled wagon or on horseback. Some settlers left their families in St. Paul and set out to explore areas to the west carrying only a few weeks of supplies to find good land for a claim.

Crossing the Minnesota River was often treacherous. In the spring of 1854, Samuel Allen, an agent for David Fuller, secured a 15-year contract to operate a ferry at Chaska. By 1895, there were three ferry crossings in operation along the river.

By 1857, towns had sprung up along the Minnesota River, increasing steamer and barge traffic to keep up with the demand for goods. Settlers began arriving by steamboat from St. Paul. The most active year for steamer traffic on the Minnesota River was 1862, when 413 trips were made from St. Paul to Carver. Steamboat captains were presented with many navigational challenges on the winding and shallow Minnesota River. By the of summer 1871, steamboat travel had rapidly declined due in part to a drought causing the river to be shallow and irregular. Travel on it was risky and often impossible. Any hope of the steamboat regaining popularity ended when the railroad arrived in the county in 1871. Steamboat traffic after 1872 was generally limited to passenger excursions when water levels were high enough for safe navigation.

A stagecoach express line was established in 1865 and was running between Shakopee, Chaska, and Carver. By 1868, a stage left Carver every Monday and Thursday morning for Waconia and Watertown. The stagecoach was one of the earliest methods of sending mail and bank transfers in Carver County.

Farmers early on used oxen to pull their wagons, but travel was slow. It was often faster to walk to a destination if it was only a few miles. It could take a day or more to make a trip to Chaska and back using oxen. As more settlers laid claim to land, rudely cleared trails appeared between homesteads, making travel easier between neighbors. For most farmwork that required hauling, farm wagons drawn by horses instead of oxen began to be used. Buggies began to appear in the county when farmers could afford the purchase. In winter, sleighs were commonly used; small ones with a single seat were called "cutters."

The Minneapolis & St. Louis Railroad Company (M&St.L) built the first railroad into and through Carver County in 1871. In August 1871, newspapers reported that track was being laid

on the 27-mile route from Minneapolis to Carver. The cost of building the line was funded by bank loans and bonds. November 24, 1871, was the grand opening of the line, with a special train arriving in Chaska before it went on to Carver and across the Minnesota River into Scott County. The Minneapolis and St. Louis (M&St.L) line was completed through Victoria, Waconia, Norwood, Young America, and Hamburg with stations in each village by 1881.

In 1872, the Hastings & Dakota Railroad (H&D), a part of the Chicago, Milwaukee & St. Paul Railroad Company, was completed to Carver. Later that same year, the line was extended to Glencoe and provided service to Norwood, Cologne, and Chaska. A branch of the H&D was constructed in 1880 to service Chaska and Carver and continued westward, connecting to the main line at Benton Junction two miles east of the village of Benton.

The Great Northern Railroad's Hutchinson branch began construction in 1885 with the Minneapolis Junction and Hutchinson, its main terminals, in operation on December 31, 1886. The railway entered Carver County at the northwest quadrant of Chanhassen Township and made its way westward, winding around the north shore of Lake Waconia through New Germany, entering McCleod County to its final destination in Hutchinson.

Direct and numerous routes providing passengers with a faster mode of transportation was now a reality, bringing many new visitors and residents to the county. Rail transportation had a tremendous impact on businesses and farmers. The ability to ship goods to more distant locations and markets that were previously inaccessible contributed to the growth and prosperity of the county.

Telegraph service was available at most depots, and bank transfers were more expeditious by rail than by stage or steamboat. By the 1870s, mail was primarily transported by rail, making mail service faster, more frequent, and more reliable.

By 1910, the automobile had begun to appear in Carver County. The September 2, 1915, edition of Chaska's *Weekly Valley Herald* newspaper proclaims that of the 86,000 automobiles in Minnesota, Carver County, with a population of slightly less than 20,000 people, had 907 licensed automobile owners. The advent of mass production made automobiles affordable to not just the wealthy. Ungraded roads were rough and rutted, making automobile travel difficult.

By the late 1920s, regional passenger flights had become available in some parts of the country. In 1931, Elmer Sell, an Army Air Service flyer during World War I, became owner of the first airplane in Carver County and eventually established a hangar and airstrip in Mayer. Another Carver County resident fascinated with flying was Clair Cornell, who in 1938 purchased the first airplane in Watertown.

The first newspaper in Carver County was the *Minnesota Thal-Bote*, established in 1857 by Fred Ortwein and Albert Wolff. Originally located in Chaska, the publication was moved to St. Paul in 1858 after completing its first year in print. That same year, Luther L. and William R. Baxter sold their interest in the *Glencoe Register* and established *The Carver County Democrat* in Carver. *The Chaska Herald*, established in 1860 by Charles Warner, is the oldest Carver County newspaper still in operation.

This chapter will take the reader for a ride by horse, steamboat, train, automobile, and plane. Try to translate a postcard and read the tiny newspaper.

Art Zabel, dressed in his Sunday best, poses before traveling by horseback for a social gathering at a neighboring farm in Camden Township. After his father August seriously injured his hand in a farming accident, Art helped work the farm and was only able to attend school for 40 days of the year. (Courtesy of Olvern [Ehmke] Vinkemeier [1918].)

The horses pulling this farm wagon are equipped with leather fly nets. The leather straps move with the animal, defending the horse against biting flies, keeping it comfortable and the riders safe from the possibility of a runaway team. Pictured here are Mr. and Mrs. Krinke, with Mildred Schuldt behind them. (Courtesy of Fritz and Jane Widmer [1914].)

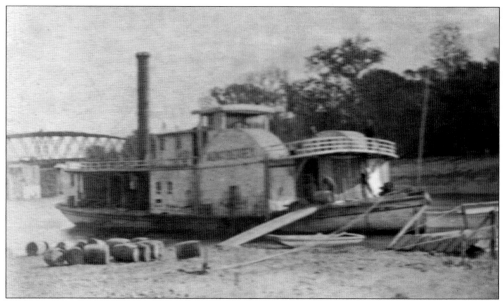

Piloting the steamboat *Aunt Betsey*, Captain Costain provided three excursions in the summer of 1878 from Carver to St. Paul, accommodating up to 200 passengers. The round-trip cost was 50¢ per person. Henry Neunsinger accidentally drowned on the July 21 excursion. On the August 18 excursion, the boat became stuck on the Mendota Bar, and the 120 passengers were forced to return home by train. This is a stereograph view of the *Aunt Betsey* on the Minnesota River at Carver. (Courtesy of John von Walter.)

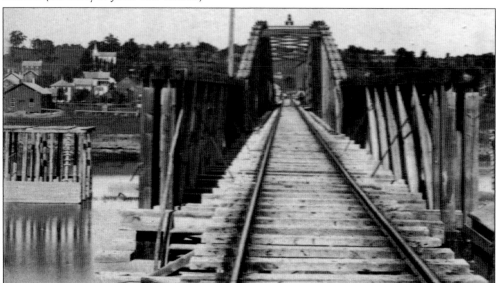

This stereograph view shows early Carver and the Minneapolis & St. Louis Railroad swing bridge from the Scott County side of the Minnesota River. Moving counter-clockwise, starting on the left on the riverbank, the structures are the Village Hall, Union Hall Saloon, Dr. William Griffin's residence, a stable, the second Carver Schoolhouse, the first Trinity Lutheran Church, the Levi Griffin/Joshua Torrey residence, the Torrey stable containing all or part of the Axel Jorgenson claim shanty and the schoolhouse for Minnesota School District No. 1, and the Suzanna Zanger residence. (Courtesy of John von Walter.)

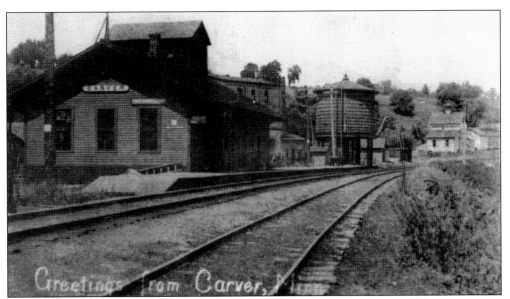

The first Carver Depot was built in September 1871 at the east end of Fourth Street East. The Minneapolis & St. Louis Railway Company installed a telegraph office at the depot in November 1877. The depot was destroyed in a fire ignited by sparks from a passing train on November 26, 1918. Structures pictured here from left to right are the Carver Depot, a barley mill, the railroad water tower, and the Minneapolis Brewing Company warehouse. (Courtesy of John von Walter.)

ST. PAUL AND MINNEAPOLIS
AND
WATERTOWN AND ABERDEEN, S. D.

READ DOWN					READ UP		
No. 11 New Ulm Pass'r Ex. Sun.	No. 15 Dakota Limited Daily	No. 13 Watertown Exp. Ex. Sun.	Miles	TABLE No. 3	No. 14 WatertownExp. Ex. Sun.	No. 16 Dakota Limited Daily	No. 12 New Ulm Pass'r Ex. Sun.
m5.05	8.40	8.55	0 ST. PAUL (U. D.)	4.10	8.10	n 8.50
5.45	9.25	9.40	12 MINNEAPOLIS, U. D.	3.25	7.20	8.10
6.04	9.44	10.05	20 Hopkins	3.00	6.55	7.48
6.09	23 Minnetonka Mills	7.41
6.16	f 9.56	f10.17	27 Deephaven	f 2.45	f 6.37	7.33
6.30	10.05	10.25	30 Excelsior	2.40	6.30	7.20
6.45	10.19	10.36	36 Victoria	2.26	p 6.16	7.06
6.57	10.34	10.48	43 Waconia	2.13	6.02	6.54
7.11	10.51	11.04	51 Young America	1.57	5.46	6.40
7.15	10.55	11.07	52 Norwood	1.54	5.42	6.37
7.22	11.04	11.15	55 Hamburg	1.47	5.34	6.31
7.32	11.16	11.25	60 Green Isle	1.39	5.24	6.24
7.44	11.29	11.38	66 Arlington	1.26	5.11	6.12

The "Minneapolis & St. Louis Railroad Passenger Train Time Table" issued on August 15, 1930, shows the train entering Carver County from Excelsior with stops in Victoria, Waconia, Young America, Norwood, and Hamburg and exiting the county to Green Isle. The morning departures were listed on the left side of the schedule and read in descending order. The afternoon and evening departure times were in bold and read from the bottom in ascending order. (Courtesy of Larry Wigfield [1930].)

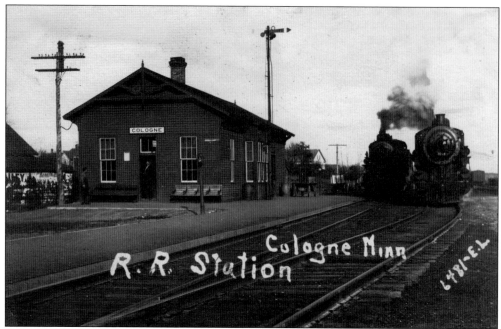

In 1872, the Hastings and Dakota Railroad (H&D), as it was called as the part of the Chicago, Milwaukee and St. Paul Railroad (CM&St.P) that passed through Carver County, built a line through Chanhassen, Cologne, and Norwood connecting Minneapolis with Glencoe. The second depot was built in 1908. Pictured here are two CM&St.P steam locomotives at the Cologne Depot. (Courtesy of Marcia Tellers [1912].)

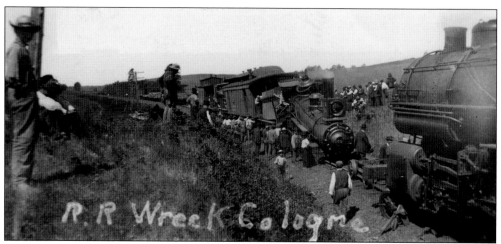

On Saturday, June 18, 1910, No. 76, a CM&St.P way freight collided with a H&D passenger train near Cologne. Reportedly caused by carelessness, the accident resulted in no injuries. However, the H&D engine sustained significant damage, as seen in this photograph. (Courtesy of Marcia Tellers [1918].)

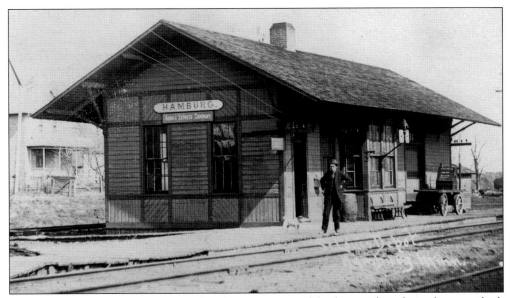

In the late 1870s, extension of the railroad to Waconia and further south and west began to look like it would be reality. As news of the extension spread, merchants began to purchase property for construction of their stores and businesses. The coming of the railroad meant people of the area would have close transportation to other towns and a shipping point for their products. The Hamburg Depot pictured here was built about 1881 and closed in 1954. (Courtesy of the Fred Bergmann/Johann J. Mueller families.)

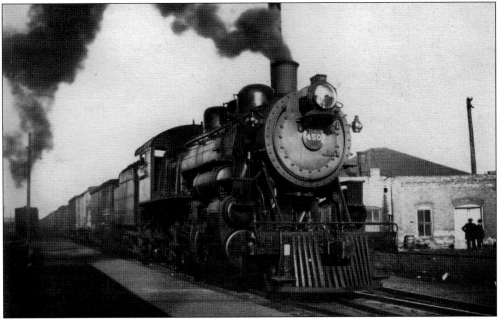

The first Chaska Depot was a frame building constructed in 1871 by the Minneapolis & St. Louis Railroad (M&St.L) to handle freight, passenger, and telegraph service. In 1911, after pressure from citizens over the inadequacy of the original depot, the M&St.L constructed a new and larger brick building. A steam locomotive, built in 1912, is seen here passing through Chaska. (Authors' collection [c. 1915].)

Traveling in the heavy winter snows could be challenging in Carver County's early days. Sleighs were an expeditious and efficient method of transportation through snow. Many sleighs could accommodate a substantial load of supplies. An unidentified traveler is seen here in a sleigh at Benjamin and Clara Lemke's farm in Benton Township. (Courtesy of Fritz and Jane Widmer [1917].)

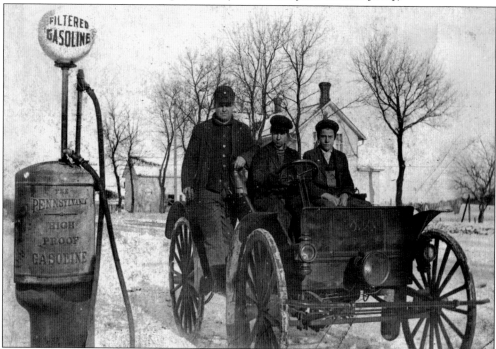

An early "high wheeler motorbuggy" or "horseless carriage" is seen here in Mayer at one of the two Sell gas pumps. These vehicles were modeled after horse-drawn buggies and often were manufactured from buggy parts. The large wood-spoked wheels with dense rubber tread gave the vehicles maximum ground clearance and tire durability on the primitive rural roads. There were over 40 American manufacturers of high-wheel automobiles, including Sears and Roebuck. (Courtesy of Charles Sell [c. 1903–1915].)

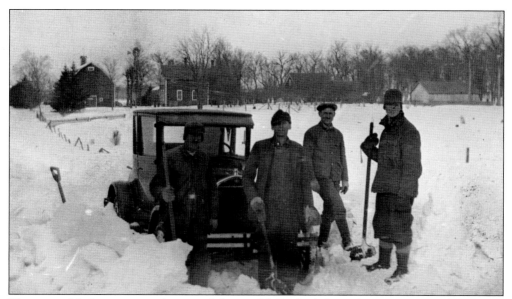

Blowing and drifting snow made automobile travel difficult. A few ambitious motorists shovel snow on the gravel road that became MN-25. The Glenn Beiersdorf farm is seen in the background to the north toward Watertown. (Courtesy of Liz Beiersdorf [1942].)

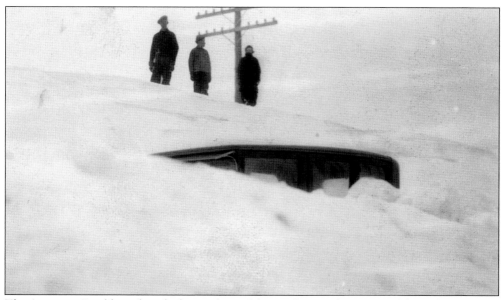

The Armistice Day blizzard, ranked second out of the top five weather events of the 20th century by the Minnesota State Climatology Office, began on the morning of November 11, 1940. Few Carver County residents were prepared for the devastating storm that produced snowdrifts exceeding 20 feet in some areas, destroyed homes and property, and killed 49 residents across the state. Pictured here is Audubon Road in Chanhassen. (Courtesy of Judy Koch [November 1940].)

No. 313. Along the Yellowstone Trail, near Waconia, Minnesota.

The Yellowstone Trail was the earliest transcontinental highway stretching from Plymouth Rock, Massachusetts, to Puget Sound, Washington. At the beginning of the 20th century, many roads were no more than a wagon trail, and travel of any distance by automobile was impossible. In 1912, J.W. Parmley and a group of businessmen from Ipswich and Aberdeen, South Dakota, wanted to create a better and safer route for motorists between their two towns. Within weeks, the idea expanded to become a route to Yellowstone National Park. Eventually, the route spanned the entire upper portion of the United States. The Yellowstone Trail entered Carver County in Norwood on Highway 212 and passed through Young America and continued on MN-5 through Waconia. Although The Yellowstone Trail Association did not construct roads, it implemented road markings, created and distributed maps, and the government lobbying efforts of the association resulted in improved road conditions. The association was active from 1912 to 1930. (Both courtesy of the Kim Mackenthun family [c. 1912].)

No. 317. Along the Yellowstone Trail, near Waconia, Minnesota.

In this postcard, written in German, a citizen of Cologne sends a friend in Gaylord a Happy New Year greeting posted on January 2, 1893. In 1873, these early postcards became available and were issued exclusively by the US Postal Service. In 1893, private printing companies gained the right to print postcards that met the government requirements and qualified for the reduced 1¢ postal rate. (Courtesy of Marcia Tellers [1893].)

The "Saluting Young America" stamp issued by the US Post Office was to celebrate the youth of America, but that did not prevent the town of Young America from sharing the spotlight. On September 1, 1948, Cora Arnold, assistant postmaster at Young America, hand cancelled and placed the special Youth Month cachet on more than 5,000 envelopes sent to the post office by stamp collectors from as far away as Brazil and New Zealand. (Authors' collection [1948].)

The Sell Flying Field, owned by Mayer pilot Elmer Sell (seen in the upper half of the photograph), was Carver County's first airport. The log farmhouse at the airport was converted into a hangar that was remodeled to accommodate three privately owned airplanes. A portion of the houses in Navajo Heights, an addition platted in 1927 by Elmer's father, O.D. Sell, can be seen along MN-25. (Courtesy of Charles Sell.)

Mayer postmaster Clarence H. Guetzkow wrote this letter to Elmer Sell to express his appreciation for Elmer's efforts in making the first successful airmail flight from Mayer on May 19, 1938. The letter posted the morning of the flight by Guetzkow was onboard so that Elmer would have a memento of the historic event. (Courtesy of Charles Sell [May 1938].)

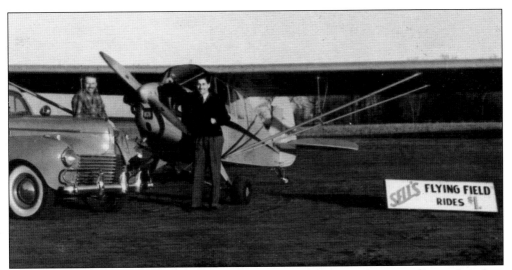

Elmer Sell served in the Army Air Service during World War I and as a co-pilot and civilian instructor during World War II. In 1922, he performed a daring wing walk over New Germany, and over the years hundreds of citizens took flight with Elmer for a breathtaking view of Carver County. For a mere dollar, folks could enjoy what for some was a once-in-a-lifetime experience. Pictured here are Elmer Sell (left) and Gordon Volkenant. (Courtesy of Charles Sell [1956].)

At the beginning of World War II, the National Guard took possession of Sell Airfield in Mayer to secure it against the possibility of infiltration by enemy aircraft. Soldiers were posted at the airfield and eventually were replaced by Donnie Berndt of Mayer and Leroy Olson of Carver, who were hired to guard the airstrip. In this photograph, Elmer Sell (right) presents his license to a National Guardsman when the airport was seized on December 14, 1941. (Courtesy of Charles Sell [December 1941].)

The *Waconia Patriot* editor Charles A. Reil stands beside the door to the office in the shop area; on the left is Ted Radde, John Kunze is setting type by hand from type cases, and Tony Wessale is at the foot-operated press. The door behind the stovepipe led to the living quarters. For many years, type was set in Waconia for the *Young America Eagle* newspaper and each Thursday morning shipped to Young America on the Minneapolis and St. Louis Railroad. (Courtesy of *The Waconia Patriot* [1908].)

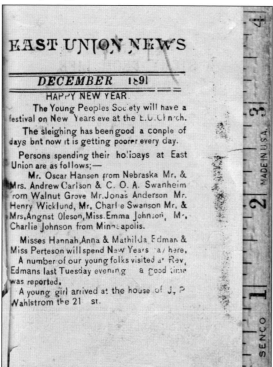

E.E. Carlson began publishing the *East Union News* in 1891. This image of the December 1891 edition illustrates the diminutive 2.75-inch-by-4.25-inch page size of the original publication. It was published monthly with a subscription price of 10¢. The small paper's page size grew larger over the years, and at some point in its history it became a bimonthly newspaper with its last edition printed in 1900. (Courtesy of Scott Hallin.)

Seven

PUBLIC SERVICE

Civic-minded citizens willing to assume public office were essential in the formation of government and the development of Carver County's early towns and villages. Early community leaders understood the importance of establishing a social structure and instituting public services for its residents. Efforts were focused on planning new roads, establishing school districts, and expanding commerce. Involvement in politics was attractive to many early businessmen who had a vested interest in the growth and expansion of the county and their community.

The first post office in what is now Carver County was established at Chaska. Thomas B. Hunt was appointed postmaster there on October 3, 1854. It was located in Fuller's store at the levee in Chaska. The contract called for monthly mail delivery with a pony rider making the trip from Mendota. The following is a list of early Carver County postmasters, including their locations and appointment dates:

Andrew Berquist	May 22, 1856	Scandia
Joseph A. Sargent	June 5, 1856	Carver
James M. Davis	August 8, 1856	San Francisco
Isaac Berfield	September 10, 1856	La Belle
Robert M. Kennedy	October 25, 1856	Young America
George W. Hamilton	December 16, 1856	St. Clair

An additional nine postmasters were appointed in other locations by the end of 1863.

With the arrival of steamboats on the Minnesota River by 1862, mail arriving by steamer improved delivery. Settlers outside of Chaska and Carver received mail semi-weekly, while those in Chaska and Carver received it six times per week. By 1882, Chaska received four mail shipments daily by railroad and stagecoach. The stagecoach serviced the towns not located on the railway line. Postal carrier G.C. Lee delivered the mail three times a week on foot to the residents of Chaska. Post office locations during these times moved as the postmaster appointment changed. Later, post office locations became permanent.

The health and well-being of Carver County residents has been the focus of the many physicians who have practiced in the county. In 1850, the average life expectancy for a man reaching the age of 20 was about 58 years. Accidental injuries, influenza, mumps, tuberculosis, diphtheria, and typhoid were among the many threats to the health of the residents. The services of a physician in Carver County were not available until 1857, when Dr. William A. Griffin settled in Carver

and set up a permanent practice. Dr. Griffin received his diploma from Dartmouth College in 1853. He was the examining physician for the county during the Civil War, was the first justice of the peace in Carver, and later held offices of president and treasurer of Carver. By 1882, other practitioners had set up practices in Watertown, Waconia, Carver, and Chaska to provide medical care to the citizens of Carver County.

Early 1900 brought the reality of hospitals to the county. In 1901, Dr. E. E. Shrader rented the Litfin house in Watertown with the intention of operating a hospital. In 1928, he sold it to Dr. John Lee, who in 1941 sold it to Dr. James W. Bratholdt. He renamed it Bratholdt Hospital and it operated until 1958, when Watertown Community Hospital opened its doors. In 1903, Aug. Truwe, Julius Truwe, E.O. Bachmann, and H.L. Simons founded the Young America Hospital. Dr. Eisengraeber became one of the incorporators of the hospital along with the two Truwes and Bachmann. In late 1904, the hospital fell under the direction of Dr. Ovide Martel, and by 1905 it became known as Carver County Hospital and became a treatment center. The building was torn down in 1950. Watertown's Cottage Hospital was built in 1905 by Dr. Harry A. Halgren. In 1957, the hospital provided service to its last patient.

The danger of fires was a constant worry for early residents of the county. It was often after experiencing a number of devastating fires that communities organized fire departments. Chaska was one of those communities. After a series of destructive fires in 1875, the village committed to having a fire department and accomplished this in early 1876 with the formation of a hook and ladder company. By 1877, the company consisted of 40 men as allowed by their charter, and in 1878 an engine house was added to the fire department. A brick firehouse was built in 1883. Early fire equipment included hand-drawn water pumpers and hose carts. Cisterns were dug for water supply, and the water was siphoned out of the cistern onto the fire. The fire departments of other communities were organized as follows:

Watertown	1878
Waconia	1880
Cologne	1890
Young America	prior to 1894 (records were lost or destroyed)
New Germany	1901
Mayer	1900
Hamburg	1907

On April 12, 1861, the Civil War began with the first shots fired on Fort Sumter. Within three days, President Lincoln issued a proclamation calling for 75,000 volunteer militiamen. Minnesota was assigned a quota of one regiment of infantry to be recruited. Recruiting began, and the First Minnesota Infantry took shape. Ten men from Carver County left their frontier homes for St. Paul and Fort Snelling, enlisting in the First Minnesota Infantry; two of those men died at Gettysburg. This began the history of Carver County citizens answering the call to serve their country. These heroic veterans have participated in every major US military conflict. Beginning with the Civil War, they have been engaged in some of the fiercest and most decisive battles in the history of this country at Gettysburg, Chickamauga, the Battle of the Bulge, Iwo Jima, Okinawa, the Battle at Guadalcanal, and the beaches of Normandy. Whether serving their country in combat or in times of peace, all that have donned the uniform of the US military are heroes for their willingness to defend the country's core ideals and pay the ultimate price for freedom.

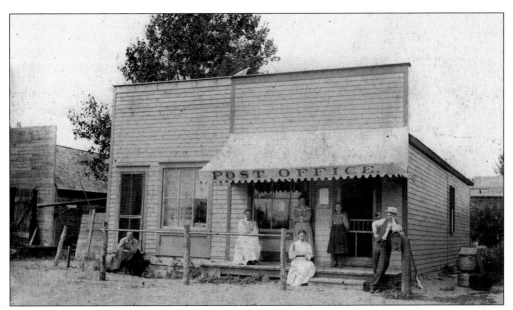

The Bevens Creek Post Office was established in April 1873. Civil War veteran Andrew J. Carlson served as postmaster from 1873 to 1893 and 1897 to 1903. In 1873, the post office was moved to East Union. In 1875, the name was changed to the East Union Post Office. A.P. Mellquist served as postmaster from 1893 to 1897. The post office closed in 1903 when a rural route from Carver was established. (Courtesy of Scott Hallin.)

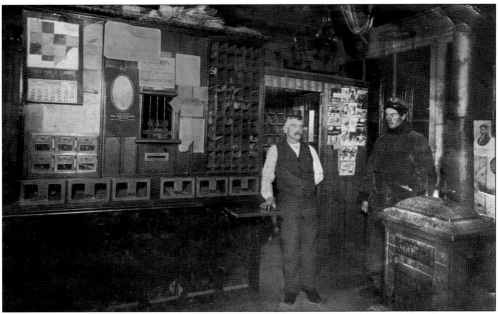

In December 1881, Hamburgh's first postmaster was appointed. Postal service records show a spelling name change to Hamburg in May 1892. Appointed postmaster in December 1901, Henry Dreier served in that capacity until July 1925. Pictured are postmaster Henry Dreier (left) and mail carrier Ed Beneke Sr., who hauled mail from 1908 to 1946. For many years, he made his rounds delivering mail using a buggy pulled by a pair of horses. (Courtesy of Ed Beneke Jr. [December 1909].)

Built in 1900, the lower floors of the Cologne City Hall were divided into rooms and the upper floor left as one large room, making it one of the largest ballrooms in the county. A Grand Opening celebration was held on February 2, 1901. City council meetings and those of many organizations, including a 1905 State Farmers Institute—the state's traveling school of agriculture—were held in the building. (Courtesy of Marcia Tellers [1907].)

Built at a cost of around $5,500, on September 12, 1908, the two-story redbrick Hamburg City Hall was dedicated with a program of speeches and a grand ball that evening with the Behrns Orchestra of Chaska providing music. The main floor was used by the city council, had room for jails cells, and housed fire apparatus. The second floor was used for public gatherings and included a stage. (Courtesy of the Fred Bergmann/Johann J. Mueller families.)

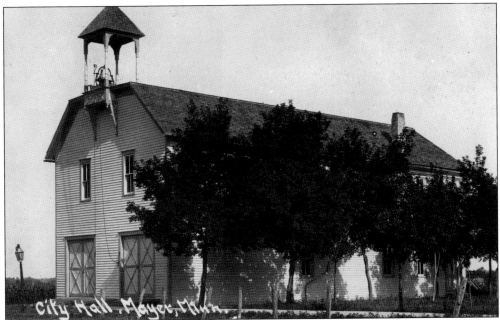

G. J. Lenz built the Mayer City Hall at a cost of $1,560. The Mayer Fire Department held a grand opening on October 26, 1901. Music was furnished by the Kelso Band and Orchestra and the Watertown Silver Cornet Band. In 1905, outhouses were added and used until 1955 when restrooms were installed. The fireman's bell seen at the top of the building was added in 1907 at a cost of $60. (Courtesy of Liz Beiersdorf [c. 1910].)

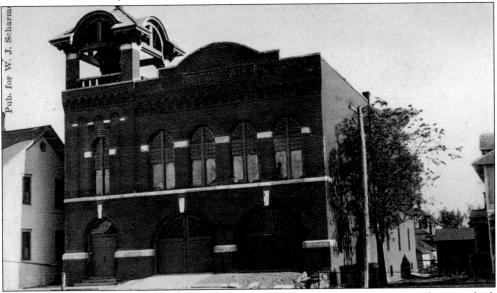

On September 17, 1909, the cornerstone of the Waconia City Hall structure shown here was laid. The prior building was completely destroyed in a tornado on August 20, 1904. The cornerstone was removed on January 10, 1953, for extensive remodeling of the building. A cornerstone box containing coins, pictures, a 1909 copy of *The Waconia Patriot*, and other papers deposited for future generations was found. The entire contents of the box were placed in the new cornerstone. (Courtesy of the Kim Mackenthun family.)

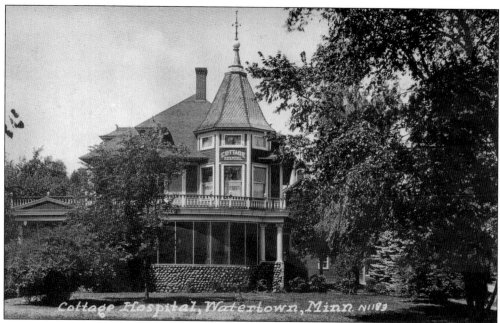

An 1897 graduate of the University of Minnesota Medical School, specializing in surgery, Dr. Harry A. Halgren built Cottage Hospital in Watertown in 1905. It housed an operating room and 6 to 10 patient rooms. It also served as his family residence. The building had a coal-fired furnace that had to be stoked at least once a day. The wood stove in the kitchen was used to cook both patient and family meals. The services of the hospital ended in 1957. (Authors' collection.)

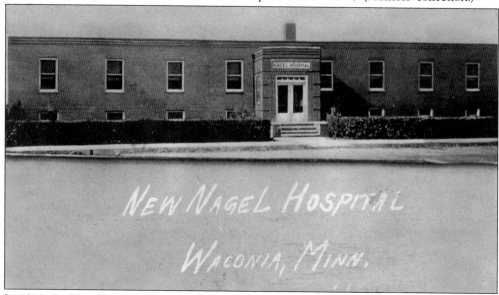

In 1940, Dr. Harold D. Nagel founded the Nagel Hospital in Waconia and was assisted by his wife, Edith, in the management of the hospital. In 1954, Dr. Nagel retired. On October 6, 1954, the Waconia Community Hospital Association was formed and 10 days later assumed operation of the hospital. Renamed Waconia Community Hospital, it served the area until July 27, 1963, when Waconia Ridgeview Hospital opened. (Courtesy of the Emma Anderson Mellgren family [1940].)

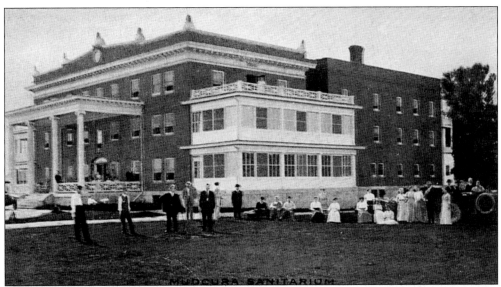

Dr. H.P. Fischer practiced medicine in Shakopee, Minnesota, for 17 years. He was told of a sulphur spring in Carver County and had read of the curative powers of sulphur-impregnated soil. This was the foundation for establishing the Shakopee Mineral Springs Co. and building Mudcura Sanitarium. Opening on July 26, 1909, Mudcura drew patients from Minneapolis, St. Paul, adjoining states, and abroad. Increasing demand for services resulted in expansion of the facility in 1912 and 1913. Located on 120 acres, a large herd of Holstein cattle provided pure milk to the patients, Belgian horses hauled the mud, and poultry supplied the kitchen. Dr. Fischer died in 1940. In 1951, his wife, Minnie, deeded the property to the Province of Our Lady of Consolation. Assumption Seminary and College occupied the site until closing in 1970. The site is now Seminary Fen SNA, a Calcareous fen, one of the rarest types of wetland in the United States. (Both authors' collection [above, c. 1914; below, 1937].)

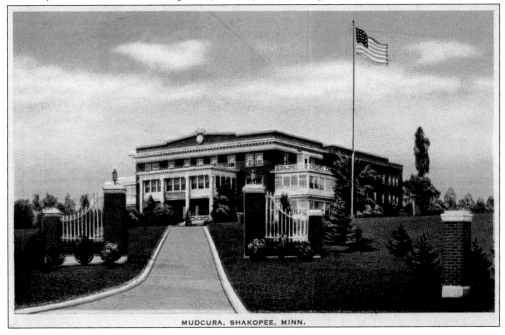

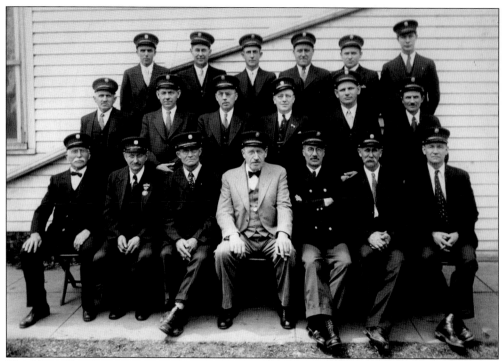

The Mayer Fire Department was organized on December 12, 1900. In 1901, fire apparatus was housed in the Mayer City Hall. Members and honorary members of the Mayer Fire Department are pictured here. From left to right the are (front row) R. Kratzke, H. Terwedo, W. Boehmke, A.H. Lorenz, O.D. Sell, G. Volkenant, and H.G. Lenz; (middle row) H. Zummach, A.W. Guetzkow, P. Schueneman, H.J. Hill, H.A. Ellig, and Al. Sell; (back row) E. Splettstoeszer, J.O. Grimm, L. Bury, W. Henseler, W.O. Hein, and E. Ranzinger. (Courtesy of the Leland Wyman collection [1936].)

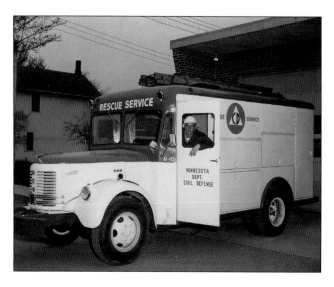

Preparedness to deal with future disasters of natural, man-made, or accidental causes was the aim of the Civil Defense Program. Leon Huckenpoehler is shown here with the Civil Defense rescue truck sponsored by the Veterans of Foreign Wars and housed at the Waconia City Fire Hall. Following completion of Federal Civil Defense training classes, he and Wilfred Schmitz taught classes in Waconia on how to handle bombed-out areas and rescue work after enemy attack. (Courtesy of *The Waconia Patriot* [1955].)

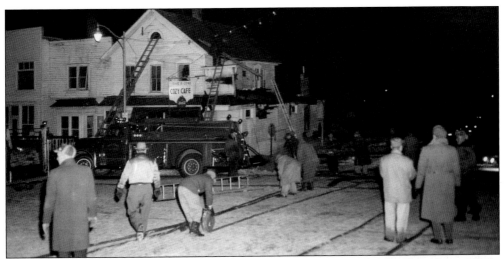

On December 26, 1955, grease in the deep fryer ignited a blaze destroying the Cozy Corner Cafe, owned and operated in Waconia by Delores Elling. Spreading of the fire was prevented, and the wall of the adjoining building owned by Susie Hanson was slightly damaged by the fire. Firemen from the Waconia Fire Department are photographed here rolling up hose following the fire. (Courtesy of *The Waconia Patriot* [1955].)

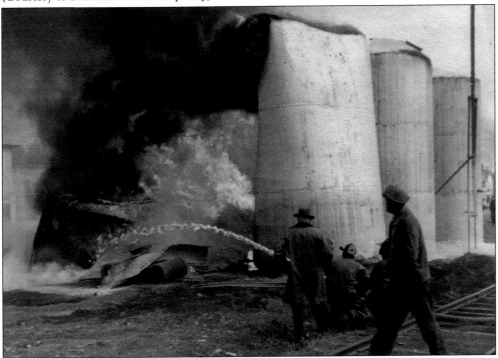

On April 12, 1946, the New Germany Fire Department, along with the Minneapolis Fire Equipment Squad and departments from neighboring towns, was photographed fighting the fire and explosions of four oil tanks at the New Germany Oil Company, which was owned by Gordon and Howard Bennyhoff. The New Germany Fire Department was organized in 1901 following two big fire losses in 1899 and 1900. Until 1902, when fire equipment was purchased, the department was a bucket brigade. (Courtesy of the David Effertz family [1946].)

CHAS. H. KLEIN

REPUBLICAN CANDIDATE
—FOR—

REPRESENTATIVE

CARVER COUNTY, 25th DISTRICT
——1904——

Mark a Cross Opposite His Name as Follows:

| Representative | CHAS. H. KLEIN Rep. | X |

Charles H. Klein (1872–1961) represented Carver County, District 25, in the Minnesota House of Representatives (1903–1905) and the Senate (1911–1913). During his lifetime, he served as a president of the C.H. Klein Brick Company, the Wunder-Klein-Donohue Company, and the Ready Mixed Concrete Company and was the owner and president of seven banks, including the First National Bank of Chaska and Waconia and Victoria State Bank. A Charles H. Klein candidate campaign card is shown here. (Courtesy of Gerald and Geraldine Poppler [1904].)

VOTE FOR

Albert Gerdsen
—>/|\<—

Prohibition Candidate

for

REPRESENTATIVE

Carver County, Minn.

Albert Gerdsen (1870–1947) was nominated by the Prohibition Party as a candidate for 25th District representative to the Minnesota Legislature. The platform on the back of his campaign card was listed as follows: The prohibition of liquor traffic; the liberal and comprehensive development of the greatest state institutions—the University of Minnesota and the general school system; public ownership or control of these public utilities that are natural monopolies; and election of US senators, president, and vice president by direct vote of the people. (Courtesy of Harriet and Ron Holtmeier [1906].)

Frederic Iltis (1842–1910) was born in France and arrived with his parents in Carver County in 1855. In 1862, he enlisted in the Minnesota 6th Infantry and was mustered out in 1862 as a full 1st sergeant. Over the years, he served in Carver County as a postmaster, county commissioner, Chaska village president, and board of education president. He represented Carver County as a Republican of District 37 in the Minnesota Legislature Senate (1895–1897). His candidate campaign card is shown here. (Courtesy of Gerald and Geraldine Poppler [1906].)

...FREDERIC ILTIS...

Republican Candidate for the
Senate From Carver County

I hereby announce myself a Republican candidate for the office of State Senator from Carver County, subject to the primary election held on Tuesday, September 18, 1906.

FREDERIC ILTIS

Many individuals from throughout Carver County have answered the call to serve their country, including these East Union soldiers of World War I. From left to right are Walter Eckstrom, Herman Melberg, Ernest Hallin, unidentified, Art Olander, Bill Olander, unidentified, George Lundquist, Albert Johnson, Ben Hallin, and unidentified. (Courtesy of Scott Hallin [c. 1920].)

SELECTED BIBLIOGRAPHY

Blegen, Theodore C. and concluding chapter by Russell W. Fridley. *Minnesota: A History of the State*. Minneapolis: University of Minnesota Press, 1963.

Carver County Historical Society. *Various Town Histories*. Waconia, Minnesota.

Fraser, Wilbur F. *Economy of the Round Barn*. Bulletin No. 143. Urbana, IL: University of Illinois Agricultural Experiment Station, 1910.

Holcombe, Maj. R.J. and William H. Bingham, eds. *Compendium of History and Biography of Carver and Hennepin Counties, Minnesota*. Chicago: Henry Taylor & Company, 1915.

Lettermann, Edward J. *Farming in Early Minnesota*. St. Paul, MN: Ramsey County Historical Society, 1961.

Mihelich, Josephine. *Andrew Peterson and the Scandia Story*. Minneapolis: the author and Ford Johnson Graphics, 1984.

Minnesota Historical Society. *Carver County Newspapers on Microfilm*. The Hubbs Microfilm Room, St. Paul, MN.

Toensing, W.F. *Minnesota Congressmen, Legislators, and Other Elected State Officials; an Alphabetical Checklist, 1849–1971*. St. Paul, MN: Minnesota Historical Society, 1971.

Wendel, C.H. *Encyclopedia of American Farm Implements & Antiques*. Iola, WI: Krause Publications, 2004.

SURNAME INDEX

www.arcadiapublishing.com

MAP SEARCH

Discover books about the town where you grew up, the cities where your friends and families live, the town where your parents met, or even that retirement spot you've been dreaming about. Our Web site provides history lovers with exclusive deals, advanced notification about new titles, e-mail alerts of author events, and much more.

Find Your Place in History.